Notre Dame... In Our Hearts Forever

Notre Dame... In Our Hearts Forever

by

Michael D. Ciletti

"In Our Hearts Forever"

M.D. Ciletti

Go Irish!

Notre Dame: In Our Hearts Forever

Copyright © 2014 Michael D. Ciletti

ISBN: 978-0-9912451-9-2

Published by
Corby Books
A Division of Corby Publishing
P.O. Box 93
Notre Dame, Indiana 46556
www.corbypublishing.com

Manufactured in the United States of America

Acknowledgments

The author is pleased to acknowledge that historical information cited in Notre Dame: In Our Hearts Forever is based on the following sources: T.J. Schlereth, The University of Notre Dame: A Portrait of Its History and Campus, University of Notre Dame Press, 1976; and Marvin R. O'Connell, Edward Sorin, University of Notre Dame Press, 2001. Quotes are taken from Jim Langford, Jill Langford, Quotable Notre Dame, Corby Books; and Mary Pat Dowling, Grotto Stories, Mary Sunshine Books.

Dedication

This book is dedicated to the Congregation of Holy Cross. Under the leadership and guidance of Fr. Edward Sorin, C.S.C., the Congregation's priests and brothers launched and labored to build what has become America's foremost Catholic university. Fr. Sorin and seven Holy Cross brothers journeyed in 1842 to the site of a pair of ice- and snow-covered lakes in northern Indiana to take possession of 524 acres of heavily forested land. Under the patronage of the Blessed Mother, they soon built what still stands as the "Old College" on the banks of St. Mary's Lake. Old College housed a dormitory, a kitchen, a dining hall, and a space for classes; other buildings were soon added to the fledgling campus. When a disastrous fire destroyed the Main Building in 1879, Fr. Sorin stood fast and rallied the University community to rebuild the Main Building. A statement in the University Archives identifies the fruits of Fr. Sorin's efforts: "Main Building and her Golden Dome stand today as a testament to the dreams, ambition, determination, handiwork, and faith of our forefathers to build one of the greatest universities in the world." Children of Catholic immigrants filled out the ranks of its student body in search of the "American Dream," and its football teams captured the attention of the entire country. Today the campus spans an area of 1250 acres, operates a robust physical plant, has approximately 125,000 alumni, and boasts of achievements in all its endeavors. The Congregation of Holy Cross is arguably the cornerstone of the University.

Appreciation

I am indebted to my wife, Jerilynn, for her encouragement of my venturing into photography in my retirement. Nearly fifty years ago Jerilynn shared with me my years as an ND graduate student, gave life to three of our five children in what used to be South Bend's nearby St. Joseph's Hospital, and with me shared an enduring friendship with my mentor, Fr. Jerry Wilson, C.S.C., who loved her spaghetti sauce. Jerilynn and I have been blessed to be part of the Notre Dame family. Her interest in, and encouragement of, my efforts often took the form of her being my cheerleader, believing that my efforts to capture the beauty of the campus could be shared with others in the form of a book. Friends and classmates were encouraging too—with their supportive words and their evident enthusiasm. At Notre Dame, the beloved Sue Shindler at the Hammes Bookstore encouraged me and led me to Jim Langford and Tim Carroll, of Corby Publishing. They saw the possibilities and agreed to publish the three-part Remembering Notre Dame series, and now are publishing Notre Dame: In Our Hearts Forever—my thanks to them for their skilled and masterful work in bringing these books to completion. Thanks also to our daughter Rebecca Ciletti for her creative assistance in editing the drafts of the book.

About the Author

The first "triple Domer" in Electrical Engineering, Michael D. Ciletti received his B.S.E.E., M.S.E.E. and Ph.D. degrees from Notre Dame in 1964, 1965, and 1968, respectively. Following graduate school he served a four-year tour of duty at the Frank J. Seiler Research Laboratory at the United States Air Force Academy. He then worked as a research engineer at Systems Control, Inc. in Palo Alto, California. In 1974, he joined the faculty of the University of Colorado at Colorado Springs, Colorado, where he developed and taught undergraduate and graduate courses in electrical and computer engineering, with a focus on microelectronics, and served multiple stints as department chair and resident dean. His textbooks in digital design are widely used, and have been translated into Chinese- and Korean-language editions. He has taught short courses for industry and academic institutions in Asia and Europe (Technological University of Delft, Netherlands). As a consultant he has worked for several high-tech companies, including Atmel Corporation, Hewlett-Packard, Ford Microelectronics, Prisma, Inc., and EMU Solutions, Inc., and has served as an expert witness in patent litigation. Upon retiring from the University of Colorado in 2010, Ciletti has pursued a deeper commitment to landscape photography. He and his wife, Jerilynn, reside in Colorado Springs, Colorado.

About the Images

All images are high-resolution originals, captured in raw format with Nikon D300, D700, and D800e digital cameras and post-processed with Nikon Capture NX2 and related software. In some cases images are a composite of multiple but differently exposed images of the same scene to better approximate the lighting experienced by the human eye, and processed for artistic expression and impact. Some images appeared in the Remembering Notre Dame series, but are presented here in a larger format. Over four hundred images of the campus, including those presented in this work, may be ordered as individual prints in formats and sizes suitable for framing. See the web site www.mdcimages.com for details.

Introduction

I write as a former student and an aging graduate. From my perspective Notre Dame is like no other place. It enters us, and we carry it in our hearts forever. At Notre Dame bonds of affection form and grow, and come with us when we leave. We carry memories of the campus and the people who became part of our lives. Fundamentally, our experiences there are rooted in the concrete, physical reality of the campus, and the sense of family that developed among our peers. The classrooms, dorms, Basilica, Grotto and Dome set the stage for our journey into early adulthood. Each and all contribute to the accumulation of our memories of Notre Dame. In this book we present visual images of the campus—images that, we hope, will awaken in each one of us our personal story of love for Notre Dame.

Many books have been written about the University of Notre Dame. Some dwell on the history of its development; others tout the glory of its achievements on the gridiron. We will not dwell at length on the history of Notre Dame, or the path that led to its prominence as a Catholic university. Instead, our purpose is to advance the premise that, for many graduates, Notre Dame becomes a love story that forms a backdrop for the rest of their lives. Parents are touched by the University too; visitors and "subway alumni" sense that the place is special. For many of us, our Catholic spirituality is anchored there. Historically, Notre Dame offered the hope and opportunity for a better life to the children of struggling immigrants; and today, its graduates are deeply involved in serving the needs of impoverished countries.

This book suggests that Notre Dame slips into the hearts of its graduates and lives there long after graduation, animating the course of their lives. These claims are not ones that can be proven with theorems or lofty chains of reasoned facts. Instead, this book approaches the argument indirectly by presenting views of the places where students, alumni, and other readers—in their own unique and personal history—will find themselves holding Notre Dame in their hearts. Admittedly, and sadly, not all students experience a life-long love for Notre Dame; but many do, and this book is written to awaken in them memories of their life at Notre Dame, and the events that opened their hearts to a relationship that has endured long after graduation.

Notre Dame is a place of beauty. I had the privilege of returning to Notre Dame to spend each fall semester from 2010 through 2013 with a team of engineers and computer scientists spinning technology from a university research project into a start-up company at Innovation Park, the University's high-tech incubator. Friends say that I got to live my dream. Indeed, I did. My wife, Jerilynn, and I were able to live at the edge of campus and listen to the marching band serenade us with their practices, walk in a few minutes to our seats at football games, and stroll leisurely around the campus. Additionally, in my spare time I was able to focus my passion for photography on capturing the sights of the campus, and create the images for this book and the three-part series *Remembering Notre Dame.* Our extended stays at Notre Dame allowed me to keep a keen eye on the weather, clouds and conditions of light, and to exploit opportunities to capture special scenes. The collection of images and the story they tell portrays as best I can the unique beauty of the campus, and I trust that the reader's heart will be touched as memories are awakened by them.

Students and visitors to the University of Notre Dame capture mental images of the campus peculiar to a particular time and its conditions of weather and lighting. The lens of a camera, when present over a longer span of time and decisive conditions of light, can gather a richer kaleidoscope of images. Such opportunities led to this book. Ordinary limitations on size and space prevented it from becoming an exhaustive treatment of the photo opportunities presented by the campus, but I trust that those images included here are worthwhile and representative. My scope precluded, too, an effort to present the myriad activities of students—the buildings are fixed, and readers can insert themselves into the scenes. Also, the selection of images includes older, iconic scenes as well as scenes that won't be recognized by anyone who hasn't visited the campus recently. The older, familiar and iconic buildings are still there, but perhaps images of newer sights will entice the reader to return to visit the campus. Lastly, my attraction to the beauty of the Golden Dome accounts for its appearing in more than one scene.

Each graduate holds a collage of memories of time spent at Notre Dame: among them are dorms, dining rooms, classrooms, walks to class, visits to the Grotto, and walks around the lakes, or the smell of brats and dogs on the game-day grills scattered around campus. Surely the roar of the crowd in the football stadium is unforgettable. No less is the bond felt at the singing of the Alma Mater. During my four semesters at Innovation Park I walked the campus in the early morning and enjoyed a feast of images of its beauty and my heart's love of the University. I could not walk past the Main Building without looking up at the 3rd floor office once occupied by Fr. Wilson, and recalling late-night visits with him, and my visits to the Grotto. I'm reminded of my prayers as a freshman, when I was uncertain whether I would achieve academic success or flunk out. Every stop at the Grotto fountain reminded

me of visits there with Jerilynn and our children, and our walks over to the lake to feed stale bread to the ducks after Mass on a Sunday morning. Now I wonder whether the ducks I am seeing are descendants of the ones fed? I remember the choked-up emotions of seeing the Golden Dome as I approached the exit from the Indiana Toll Road. I walked into the lobby of the Cushing Hall of Engineering and I stepped on floor stones that I walked on 50 years ago. I came to Notre Dame knowing that I would get an education; I didn't anticipate the broader impact that Notre Dame would have on my life, how it shaped my thinking, expanded my heart, and rearranged my priorities. Without a doubt, my life history has been shaped by Notre Dame. I suspect I am not alone in that realization.

Questions arise from the title of this book. How does a graduate of Notre Dame come to love the University? What marks the event? How does a graduate demonstrate a lifelong love for the University? What are the signs? Are they evident in the throngs that gather at the Grotto and at Mass in the Basillica on football weekends? Is it evident in alumni gatherings throughout the year? What typifies an enduring love for Notre Dame? How is love for Notre Dame lived out day to day by those who study and work there? What is the common bond that ties all of us together? Perhaps this book will give some clues. Perhaps the images of the campus will tug at your heart and awaken memories of times spent at Notre Dame, and help you find your answers to these questions.

Notre Dame is uniquely beautiful, and this book seeks to present aspects of that beauty so that a wide audience can appreciate this special place, and so that all can discover the bond that holds Notre Dame in their hearts. Many other places may attract our interest and awaken memories, but Notre Dame captures our hearts and remains there forever.

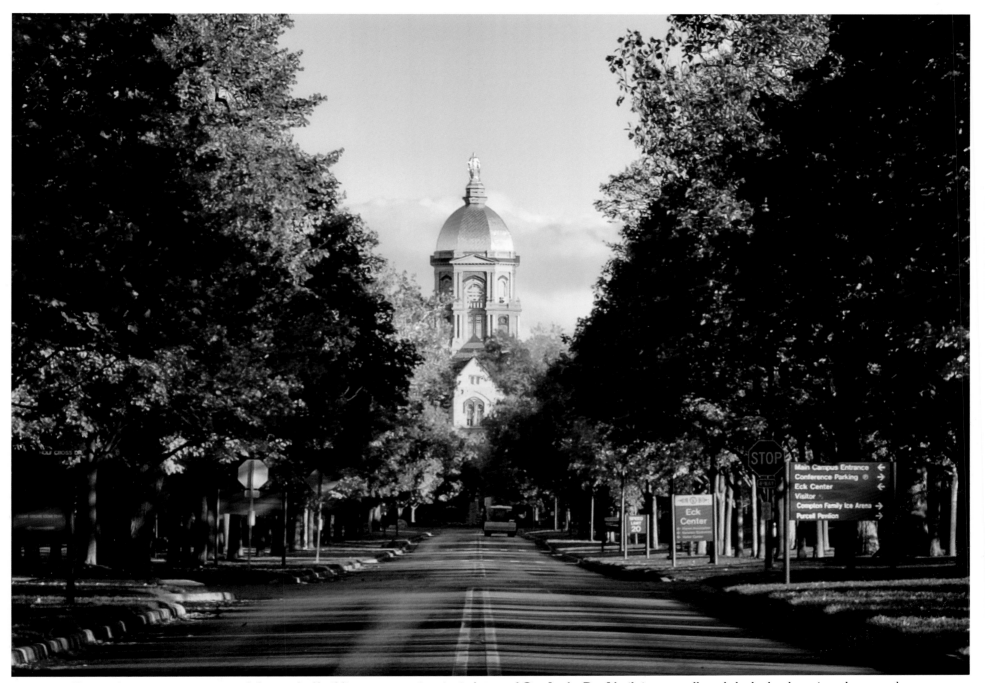

"I came here as a young man and dreamed of building a great university in honor of Our Lady. But I built it too small, and she had to burn it to the ground to make the point. So, tomorrow, as soon as the bricks cool, we will rebuild it, bigger and better than ever." – *Rev. Edward Frederick Sorin, C.S.C.*

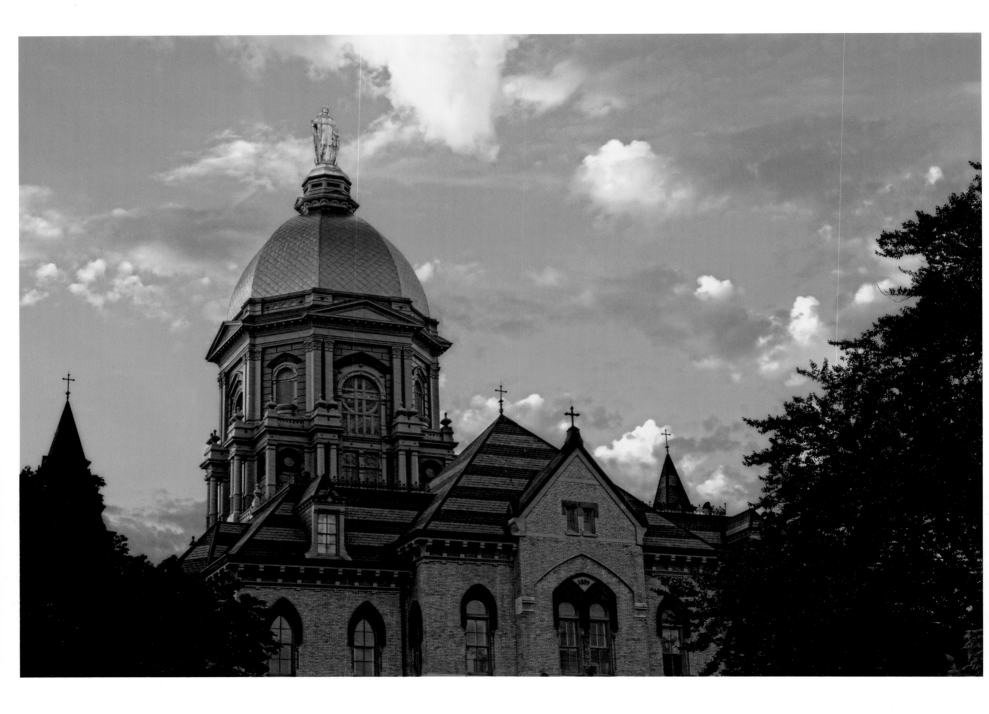

"If it were ALL gone, I should not give up." – *Rev. Edward Frederick Sorin, C.S.C.*

The Main Building, the Basilica of the Sacred Heart, and the Grotto mark the core of the campus at Notre Dame. If the campus has a signature by which all recognize it, then the Golden Dome atop the Main Building holds that distinction. All activities radiate outward from there. In the early days of the University, the Main Building was the entire enterprise, housing classrooms, sleeping facilities, and dining rooms; the academic program consisted of boarding school programs and hardly met expectations for a university. The great fire in 1879 threatened the very existence of the University. All could have collapsed into the ash heap of smoldering bricks, books and dreams, but Fr. Sorin willed that it not be so. The quickly constructed post-fire Main Building became controversial, as opinions differed about whether the dome should be painted or gilded. Fortunately, Fr. Sorin prevailed, the dome was clad in gold leaf, and became the Golden Dome. One cannot imagine today that a yellow-painted dome would warrant a second look, or feature prominently in any video imagery of the campus.

The fire that destroyed the original Main Building marks the Notre Dame family as a people whose legacy was built on perseverance, determination, and the will to fight against crushing odds, stubbornly refusing to surrender to defeat. If you are part of Notre Dame, you relish in that streak of defiance. It forms in you a posture towards the world and all within it who would crush you or steal from you your dreams and

"More than any other single event or quote in the history of Notre Dame, the spirit evidenced by Father Sorin on that day embodies for me the spirit that has never left the campus. It is a large, founding part of what makes the place a field of grace." – *Jim Langford, '59*

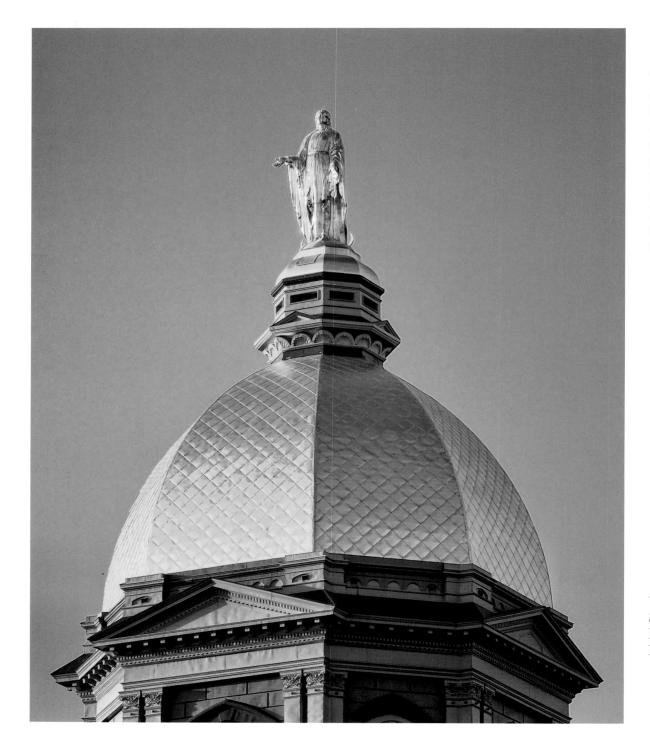

What is it about the campus that holds a deed to the real estate of our heart? Have you ever felt the excitement of seeing the Golden Dome for the first time as you drive towards campus on the Indiana Toll Road, or felt goose bumps watching the aerial view of the campus on a television broadcast before a football game? Have you ever been awestruck by the beauty of the Dome and its statue of Mary?

"It was love at first sight.
She was beautiful.
Perhaps it was infatuation.
But I proposed and she accepted."
– *Carl Massarini, '64*

At the main entrance to the campus a statue of Notre Dame, Our Lady, welcomes our arrival. We may pass by in haste and without interest, but she waits there and greets us in silence.

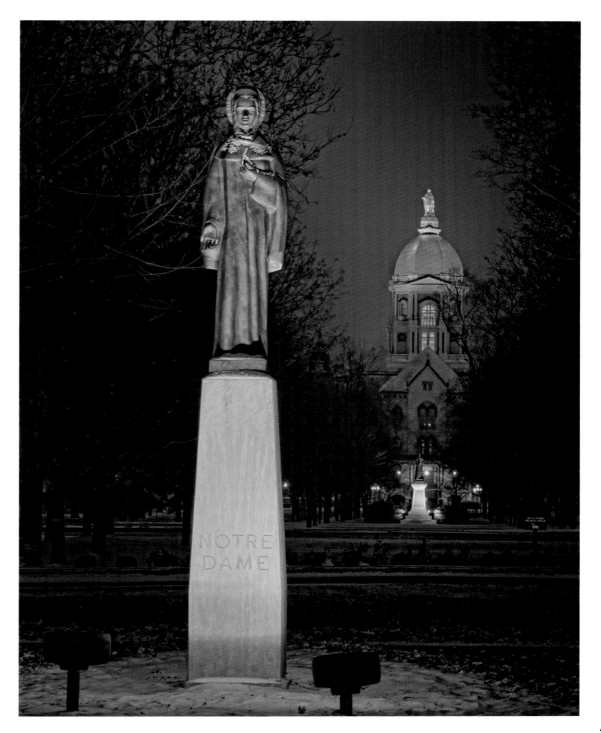

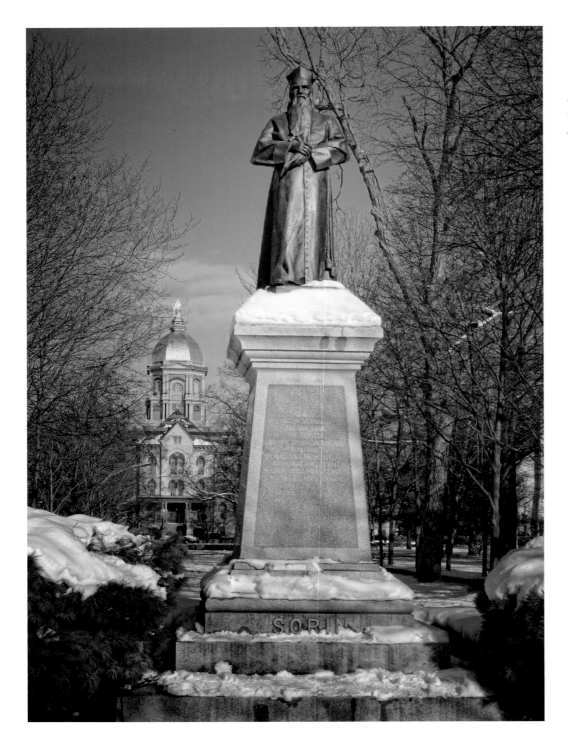

Fr. Sorin's strength, determination, and perseverance rallied others to rebuild Notre Dame after the disastrous fire of 1879 destroyed the Main Building; he envisioned that Notre Dame could be much more than anyone else at that time was able to imagine.

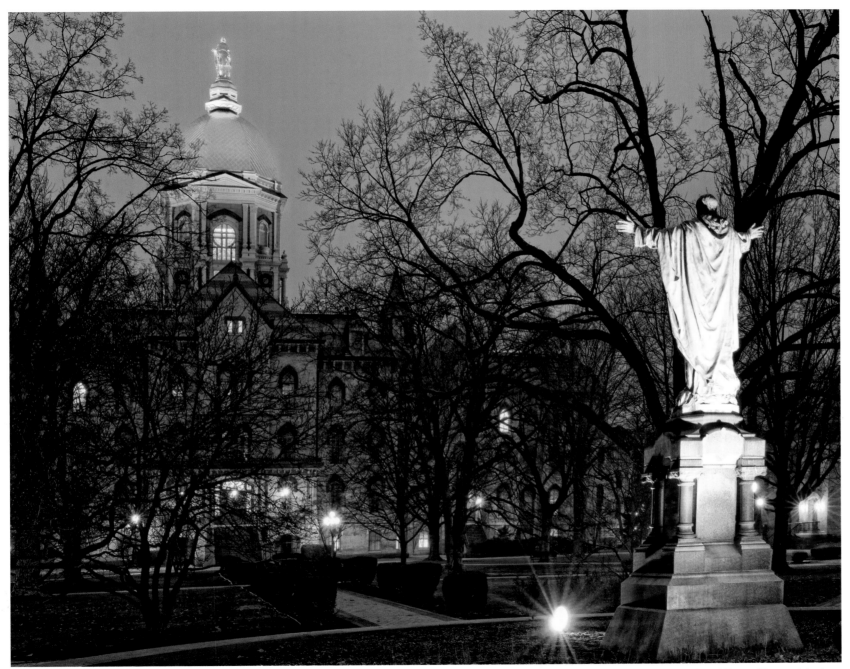

"I realize that there are some great forces at the heart of this place that daily feed my soul. One is the campus I walk on that fills itself up with the breathtaking beauty of the four seasons, each lending a change of landscape colors to buildings of all sizes, shapes, and vintage positioned along many paths." – *Jean Lenz, O.S.F.*

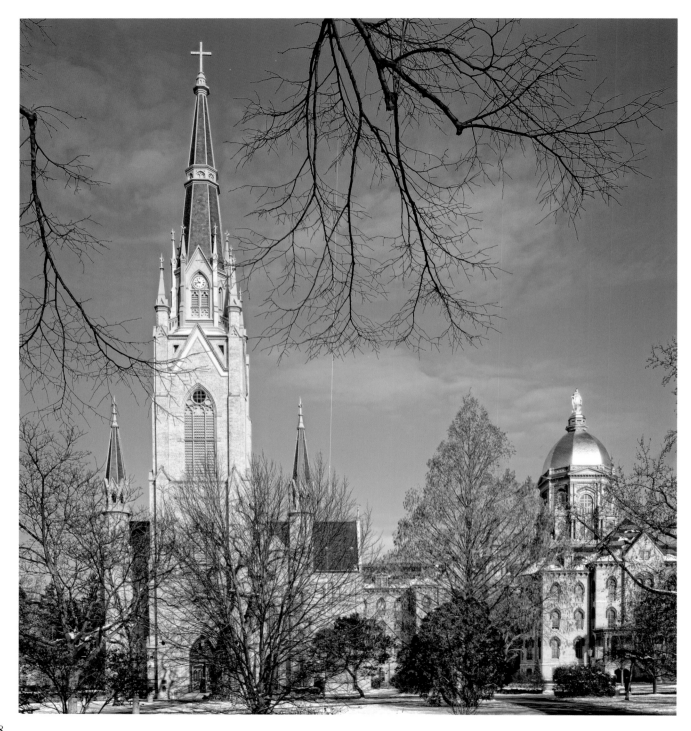

Standing beside the Main Building and the Golden Dome, the Basilica of the Sacred Heart shelters us as we ritualize our faith by participating in liturgies and quiet moments of prayer. Here is where priests of Holy Cross are ordained, their vocation exercised, and their funerals celebrated. For some graduates, the Basilica is where their marriages were celebrated, or their children baptized. For visitors, the gathering at the Basilica on Sunday mornings after a football game marks a grateful ending of a weekend of drama and reconnection with the campus.

"For those nurtured on its campus and proud of its traditions and spirit, Notre Dame evokes a sense of family...there is a bond that links the generations and makes them comfortable with the symbols, sites and songs of the place."
– *Fr. Edward A. Malloy*, C.S.C.

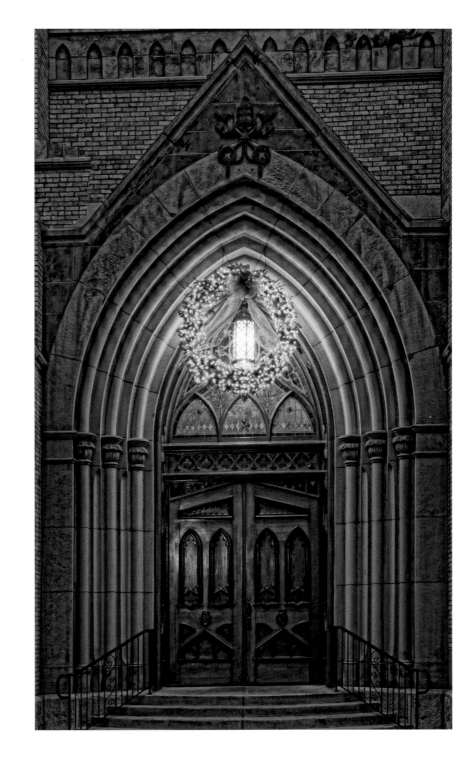

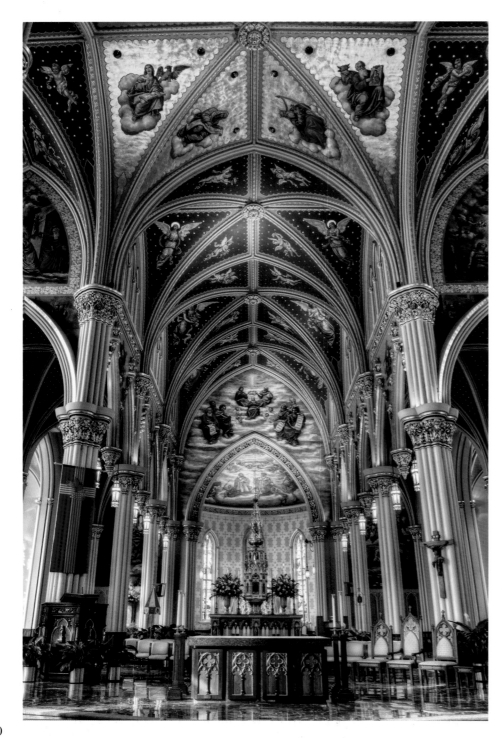

"When I return to Notre Dame now, I have a sense of coming home, even more than when I visit my native Massachusetts.... I make it a point to attend Mass in the Basilica and visit the Grotto on Sunday morning."
– *Richard Russell, '64, '72L*

Main altar – Basilica of the Sacred Heart.

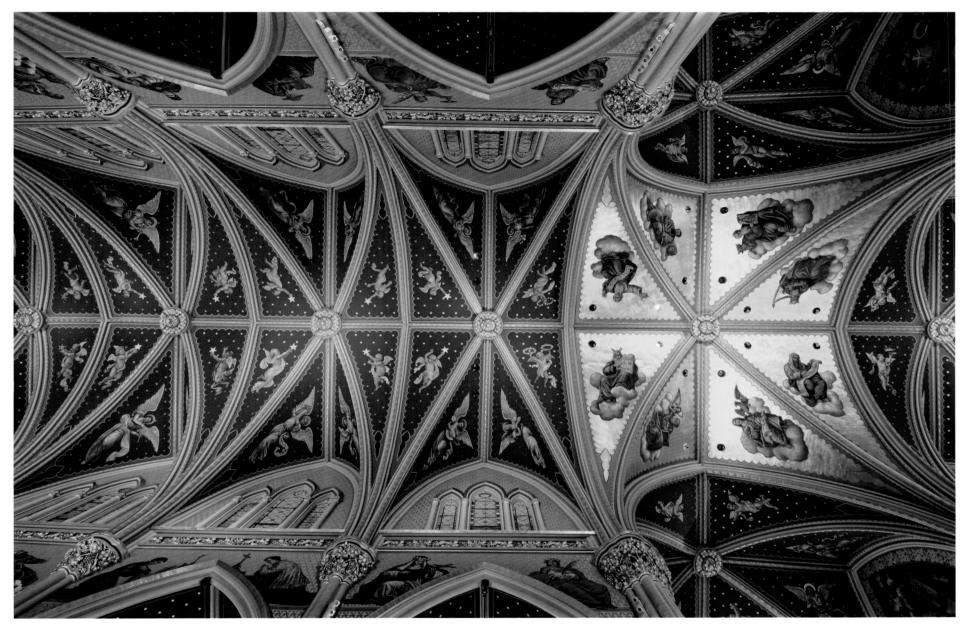

Ceiling of the Basilica of the Sacred Heart.

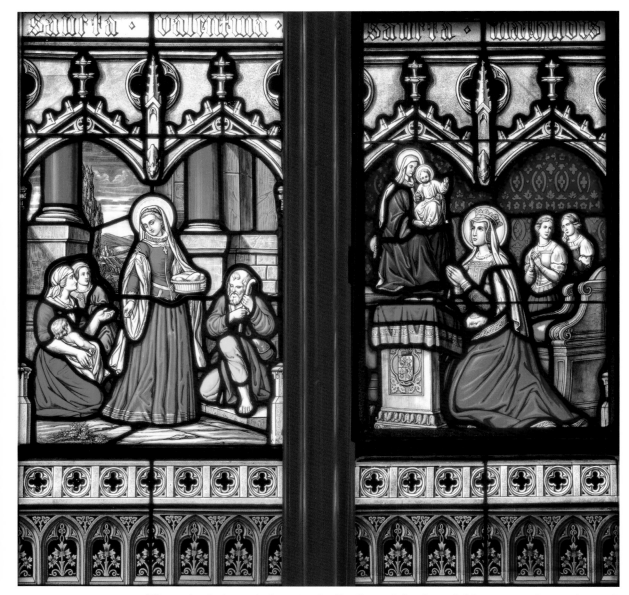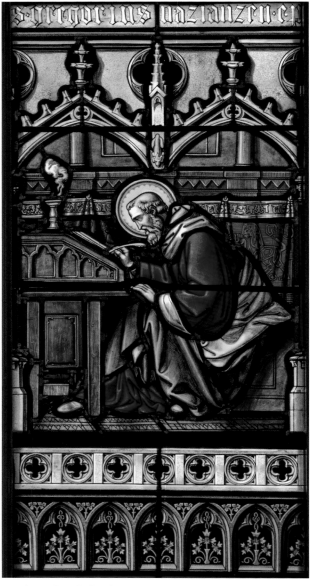

The stained-glass windows in the Basilica of the Sacred Heart are rich in color and stunning in their detail. In the left panel, Valentina, a fourth-century martyr, brings bread to the poor; in the companion panel, Matilda, the wife of the German Emperor Henry, is shown in prayer in a monastic setting; as a widow she founded Benedictine abbeys. The right panel depicts St. Jerome translating scripture into a Latin text.

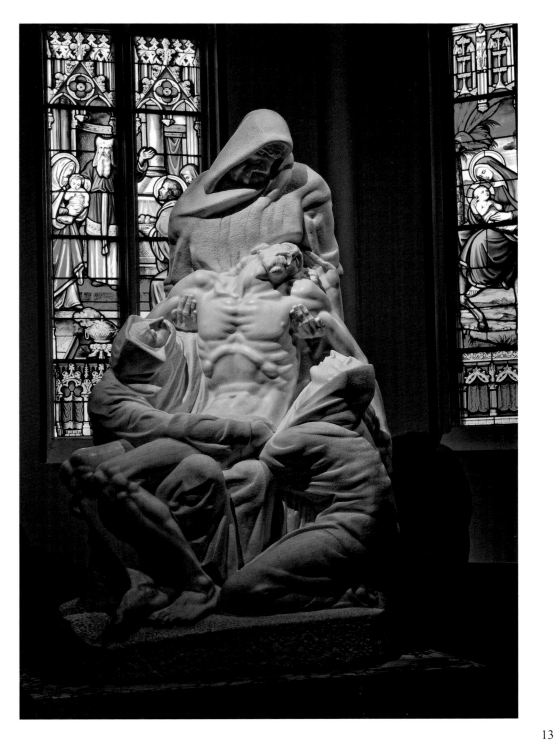

In an alcove at the east side of the
main altar sits a Pieta
by Ivan Mestrovic.

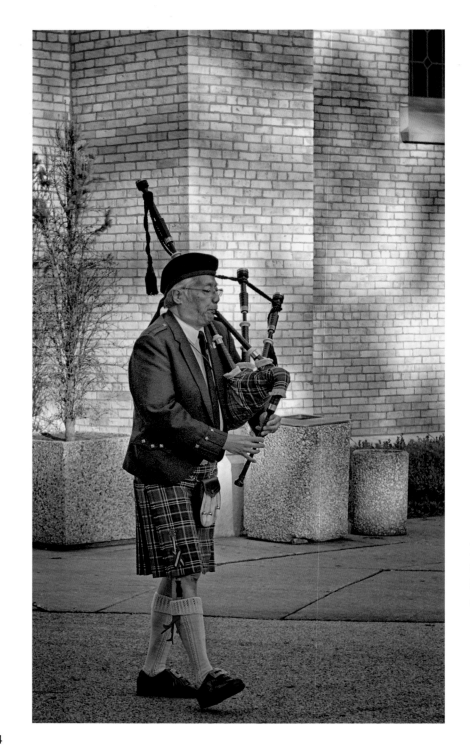

How does one explain what attracts a bagpiper to show up outside the Basilica early on a Saturday morning and present an impromptu serenade for those passing by?

"You can go to college anywhere and get a good education, but Notre Dame will change your life."
— *Kerry Temple, '74*

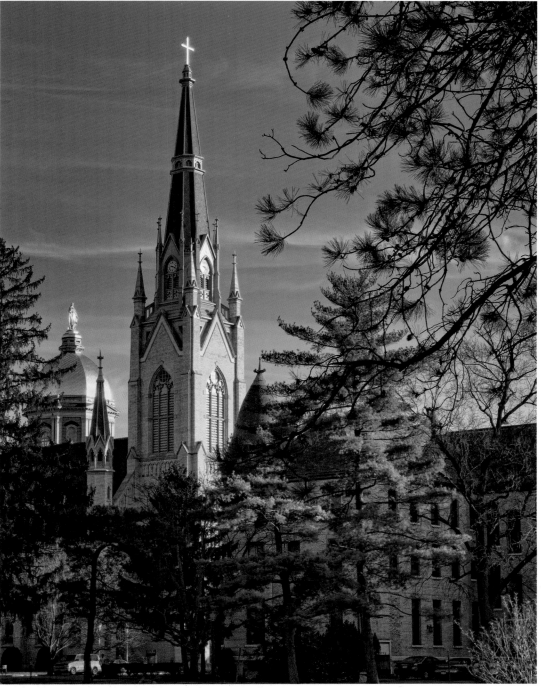

Evening light reveals a special beauty of the campus.

Northern Indiana has its share of foul weather and overcast skies, but not to be missed or underappreciated are the beautiful clouds that appear to highlight the beauty of the campus.

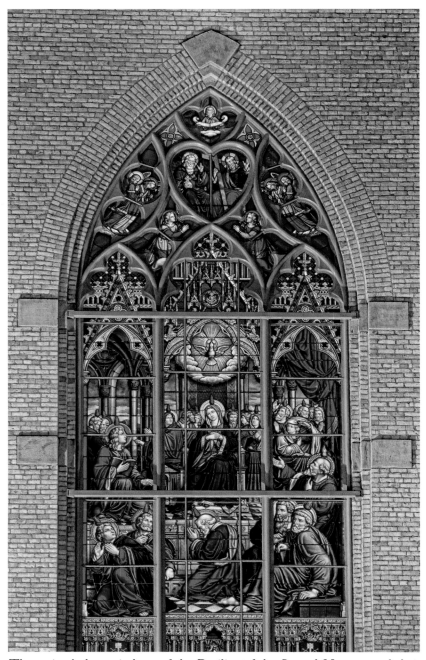

The stained-glass windows of the Basilica of the Sacred Heart reveal their beauty when illuminated from within the Basilica and viewed from outside at night.

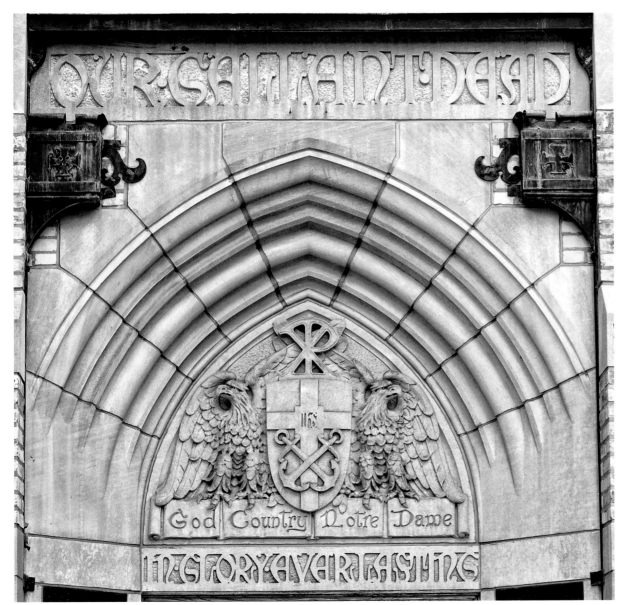
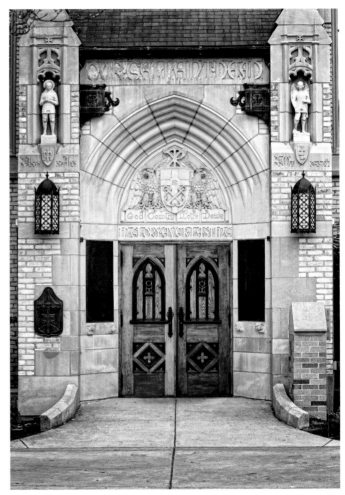

The "God, Country, and Notre Dame" relief above the east transept entrance of the Basilica of the Sacred Heart.

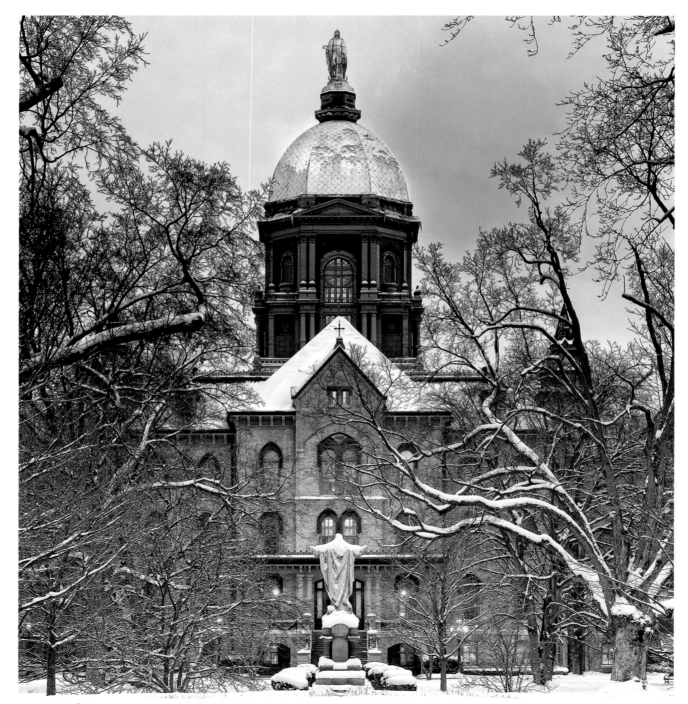

Snowstorms cover the Golden Dome in a blanket of snow, presenting a scene that has endless appeal.

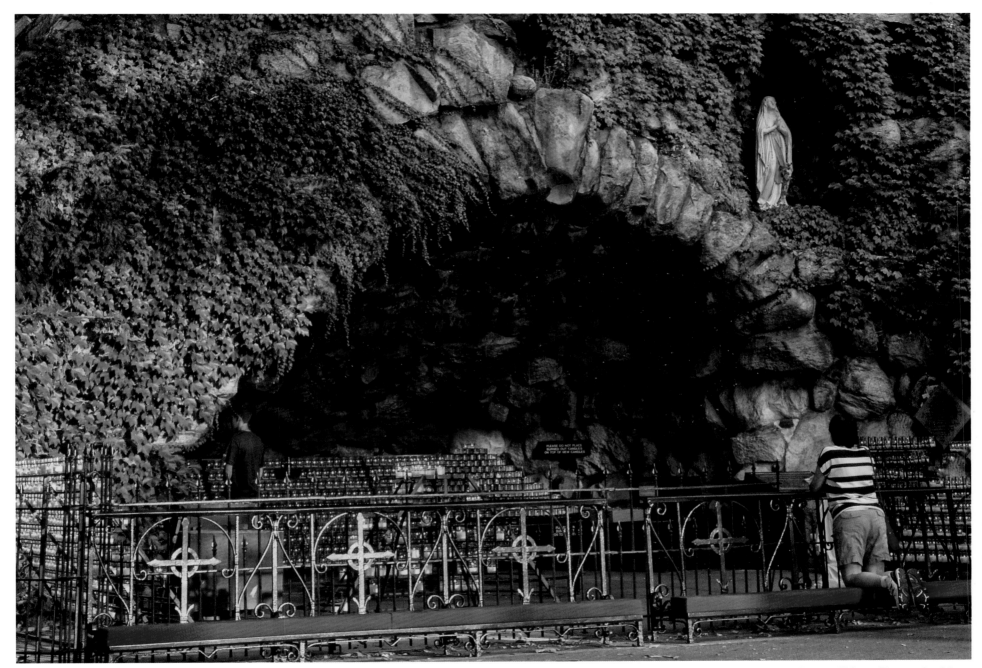

"In the shadow of the Golden Dome, tucked in a wooded hillside, there is light. A beacon of comfort for one hundred years, the Grotto is at the heart of Notre Dame. At this rocky shrine to Mary, the Mother of God, in an idyllic lakeside setting, lives are quietly touched. Countless of the faithful have brought their burdens and their thanks to the Grotto, lit a candle to prolong a prayer...found peace." – *Mary Pat Dowling, author of Grotto Stories*

"Notre Dame is in my bones for sure." – *Bessie C. Ross*

"...[L]et me tell you the secret of Notre Dame. It's not the library, as first-rate as it is; it's not the professors and courses, as stellar as they are; it's not the campus, as enchanting as it is, or even the football team, as legendary as it is. No, the secret of Notre Dame is really a person, whom we Jews call 'Miriam,' and you Christians call 'Mary.' She's there... she looks down from the 'golden dome'; and, if you really want to discover the secret of Notre Dame, visit that grotto you Catholics call "Lourdes." There's something there... no there's someone there... we call her Notre Dame, and she's the secret of her university." – *A Jewish alum as spoken to Cardinal Timothy Dolan (Commencement Address, 2013)*

"Hearts are comforted, lives are changed, and real miracles continue to happen. Faith is at the very heart of this University's life and mission, and the Grotto is at the very heart of Notre Dame." – *Most Reverend Daniel R. Jenky*

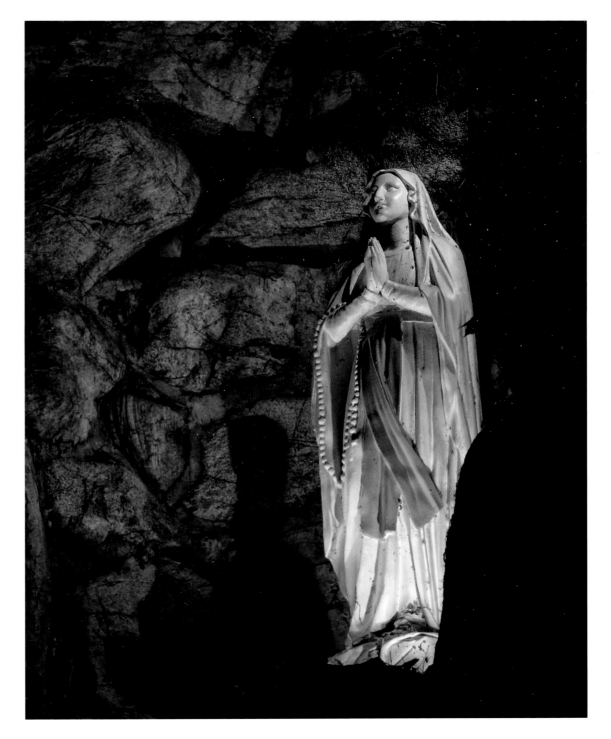

"I don't know how they get it, but they get it like three minutes after they get here—it's like a contagion for good in the air—and somehow they become bonded to this place immediately. One of the trustees used to say that this was the highest concentration of goodness of any place on earth. I wouldn't make that boast—it's a little much. But today we all stand in a special spot, and it's a special spot because it's guarded over by the Mother of God."
– Rev. Theodore M. Hesburgh, C.S.C.

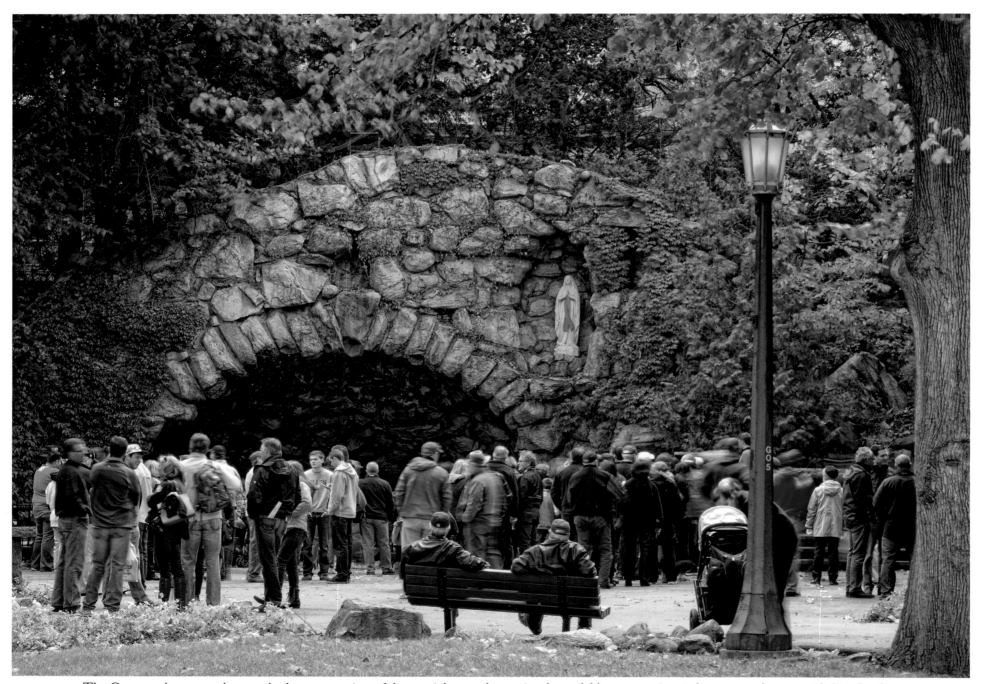

The Grotto welcomes students and others at any time of day or night—a place uniquely available to pray, sit quietly, or to rendezvous with friends who are at Notre Dame, like you, for a weekend to cheer on the football team.

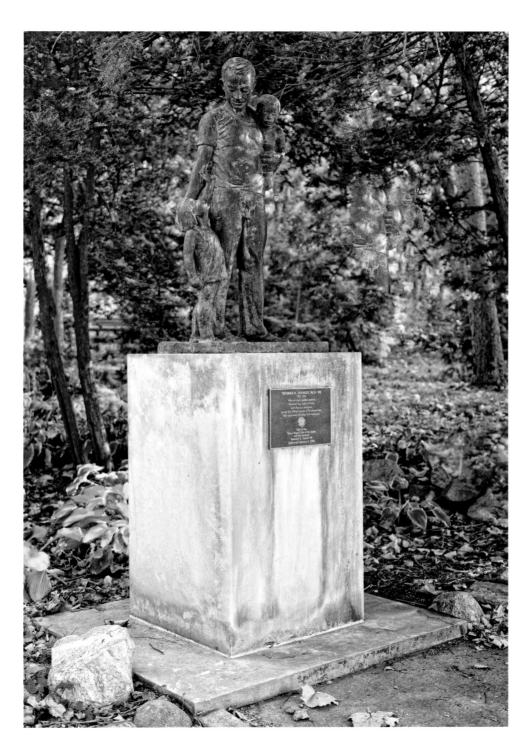

The path on the right side of the Grotto leads to a sculpture of Dr. Tom Dooley, a Notre Dame graduate who served the people of Laos as a medical missionary before succumbing to cancer in 1961. In a letter to Fr. Hesburgh, he wrote:

"...[I]f I could go to the Grotto now, then I think I could sing inside. I could be full of faith and poetry and loveliness and know more beauty, tenderness, and compassion."

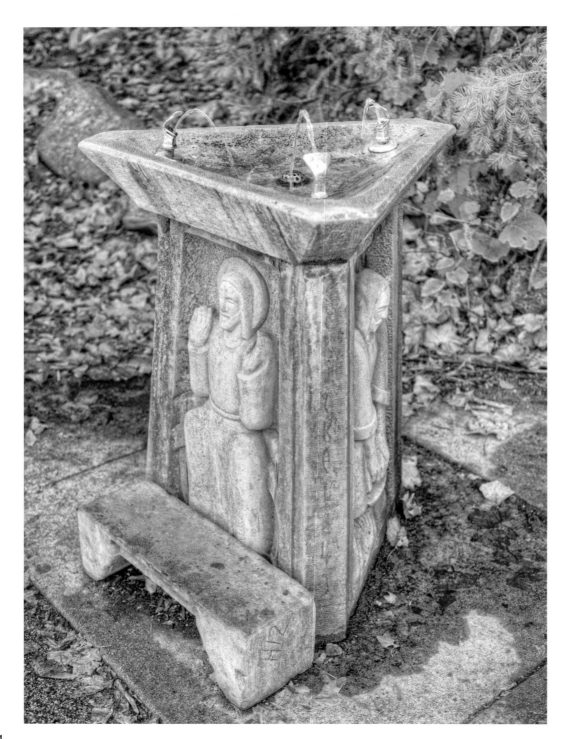

At the left side of the Grotto a small fountain with a triangular basin tickles our ears and offers cool water to all who come to visit. Children stand on a small step and catch the water; some later return to drink from the fountain again as students, and still later to introduce their children to the "Grotto fountain."

St. Mary's Lake is only a stone's
throw away from the Grotto.
Summer evenings at the Grotto offer
a peaceful silence with the sun's light
fading in the western sky.

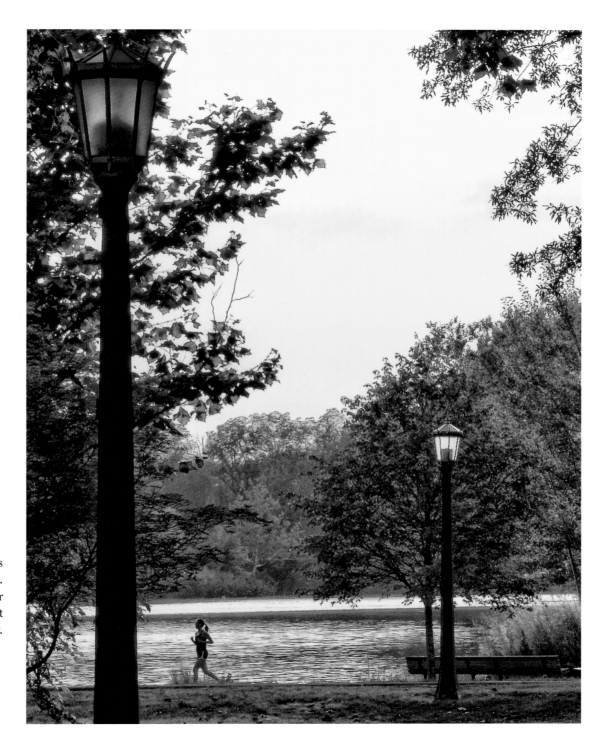

"I have been here long enough now to have seen a lot of the place, to have been disappointed in its human frailties, to have moved far beyond the rosy patina of memory, romance, and sentiment. But when I have become disillusioned or grumpy, when I have witnessed too much of the politics and personalities, I take a walk. And the campus, the very place itself, welcomes me as it did so many years ago. I have only to walk the lakes or sit alone at the Grotto or rest on a bench and watch awhile in order for the place to show itself again, to reside within me, to work its spell again. And I know then that there is something here, something about the place, something within the landscape itself, that transcends the human, that sustains the promise and the legacy, that suggests the smile of God." – *Kerry Temple, '74*

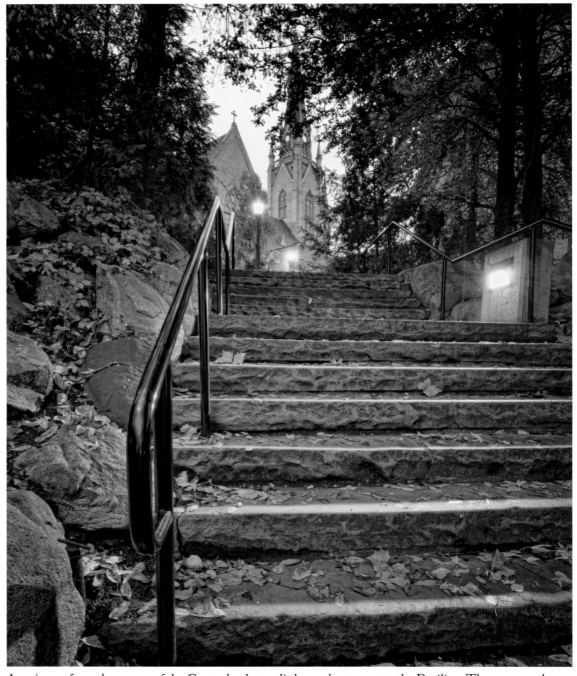

A staircase from the corner of the Grotto leads to a little-used entrance to the Basilica. The passage shown on the next page connects the Basilica and Corby Hall.

"If you want to belong, you have to learn the myth. You have to wrap your heart and mind in it. You have to believe that the merest rocks of the place tell a story.... Behind the myths is a cast of hundreds working in loyalty for the Notre Dame of their dreams, in a love affair that lasts a lifetime." – *Fr. Robert Griffin*, C.S.C.

Corby Hall provides a residence for Holy Cross priests. The "riot" of 1960 unfolded in front of the hall, leading to relaxation of all-male military school discipline, and ending morning sign-ins at the chapels and the practice of lights being extinguished in dormitories after bed checks at night. At that time, parietal hours allowed women to be in only the lobby of a dormitory, and for only a specified period of time on football Saturdays.

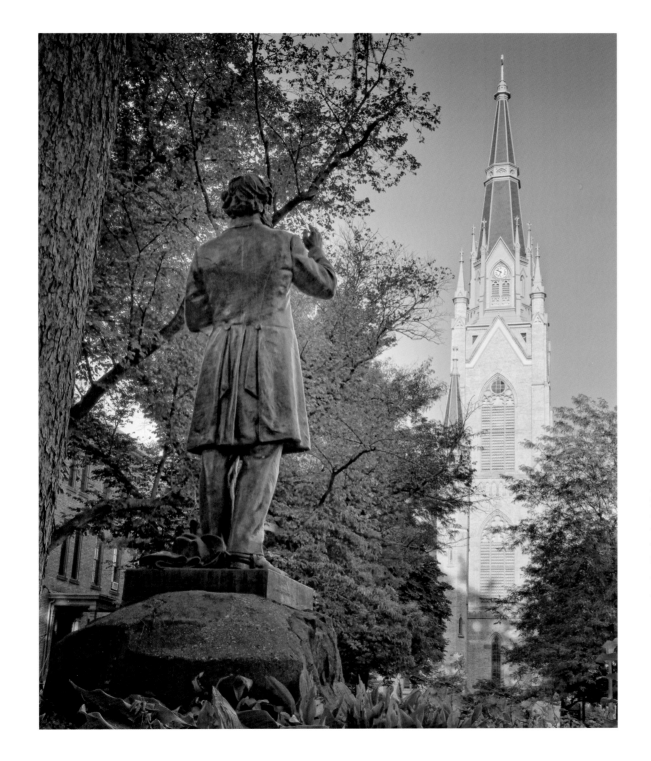

In front of Corby Hall, a statue of Fr. William Corby, C.S.C., reminds us of his granting general absolution to the soldiers of the Irish Brigade before the Battle of Gettysburg in the Civil War. Fr. Corby later served twice as president of the University.

"The work of the priests at Notre Dame may go unsung, but the priest who befriended me gave me hope, and made it possible for me to stay at Notre Dame. Fr. Jerry Wilson, C.S.C., blessed me, and later my wife, our children, and our grandchildren with his love. I can never be too grateful for what his friendship and love have meant to me. Because of him, Notre Dame became my home, and entered my heart." – *M. D. Ciletti, '64, '65, '68*

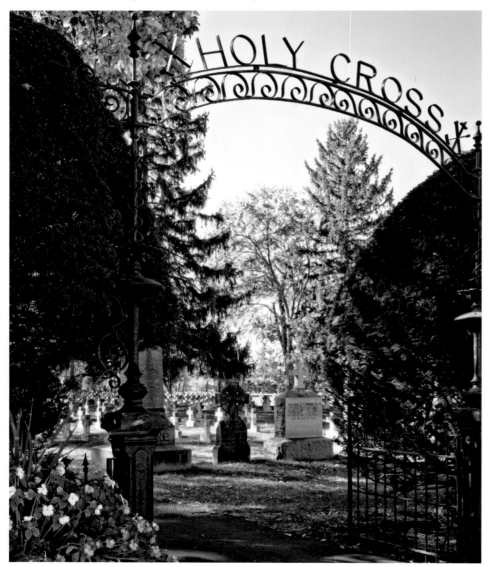

The final resting place of the priests and brothers of the Congregation of Holy Cross is Holy Cross Cemetery, located on the road between the Grotto and St. Mary's College.

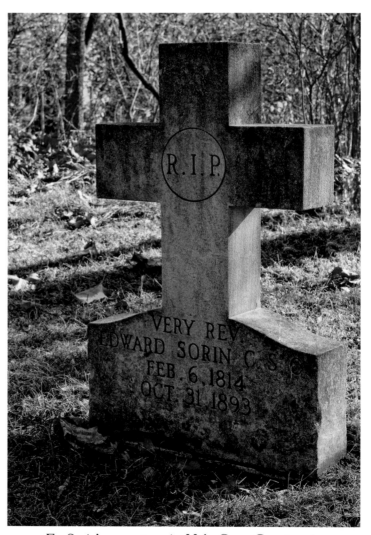

Fr. Sorin's gravestone in Holy Cross Cemetery is identical to those of his brother priests.

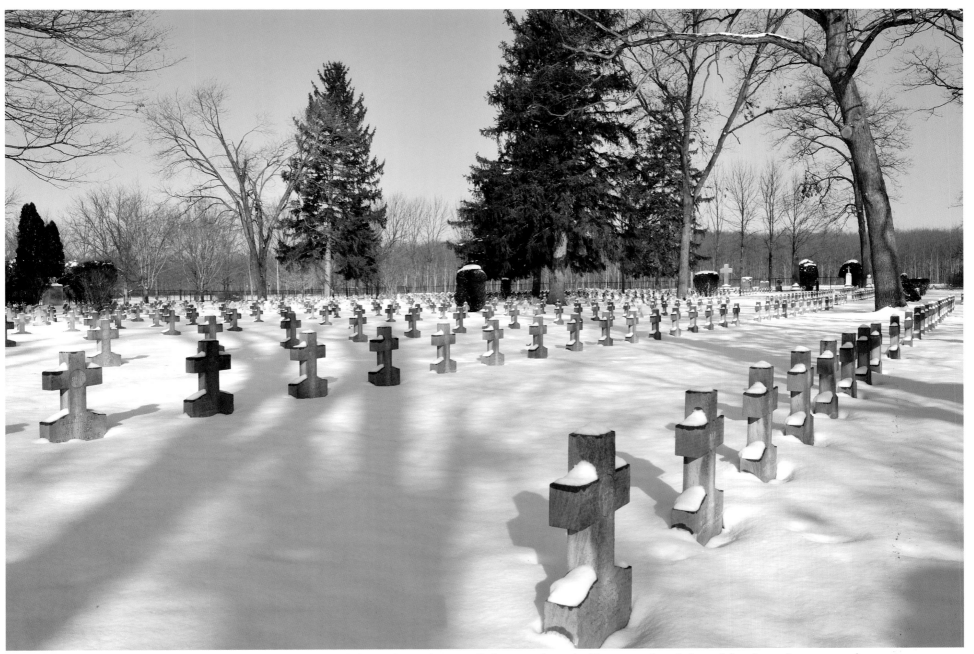

"If your heart does belong to this place and it still skips a beat when you fly home and see the Dome out the window of the plane, then you need, every now and then, to take a walk between the lakes, past Columba Hall, through the woods, to the community cemetery. It is a veritable small Normandy, all the crosses are the same size; there is Father Sorin, a cross no bigger than the rest; all the names are of now-silent heroes." – *Jim Langford, '59*

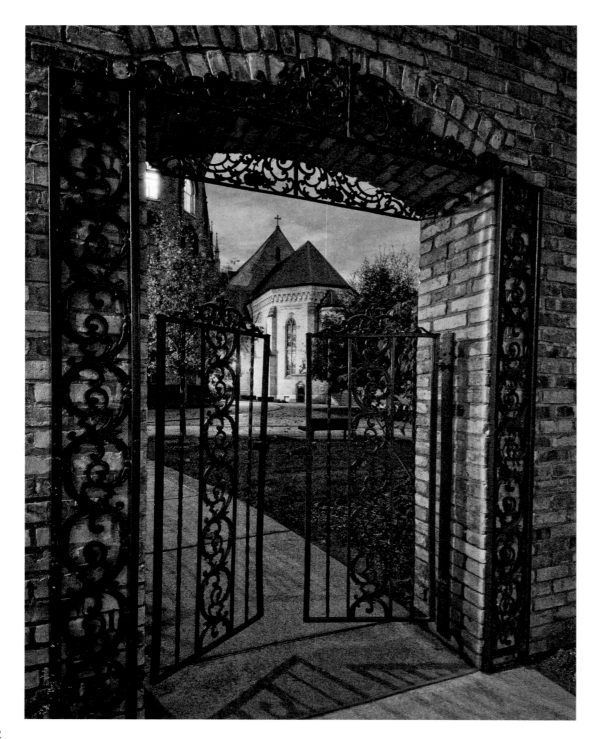

Away from the paths beaten between dormitories and classrooms, the campus has special scenes of beauty that might escape notice. Here, a gate marks a small courtyard from which the Basilica can be seen in the unique cast of early morning light.

Facing the Main Building, a statue of Christ invites us to come to him with the words *Venite Ad Me Omnes*.

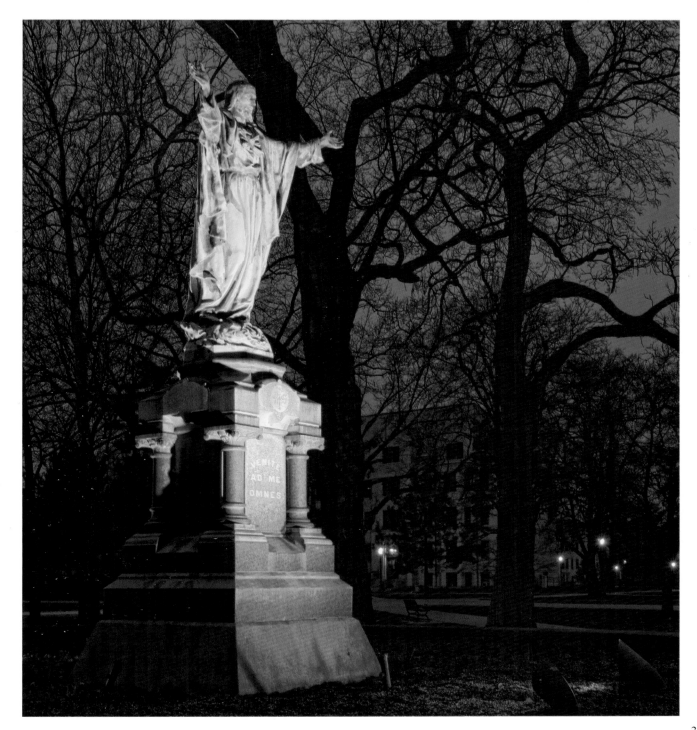

Washington Hall was built in 1881, shortly after the fire that destroyed the Main Building. It still serves the campus as a venue for talks and performances.

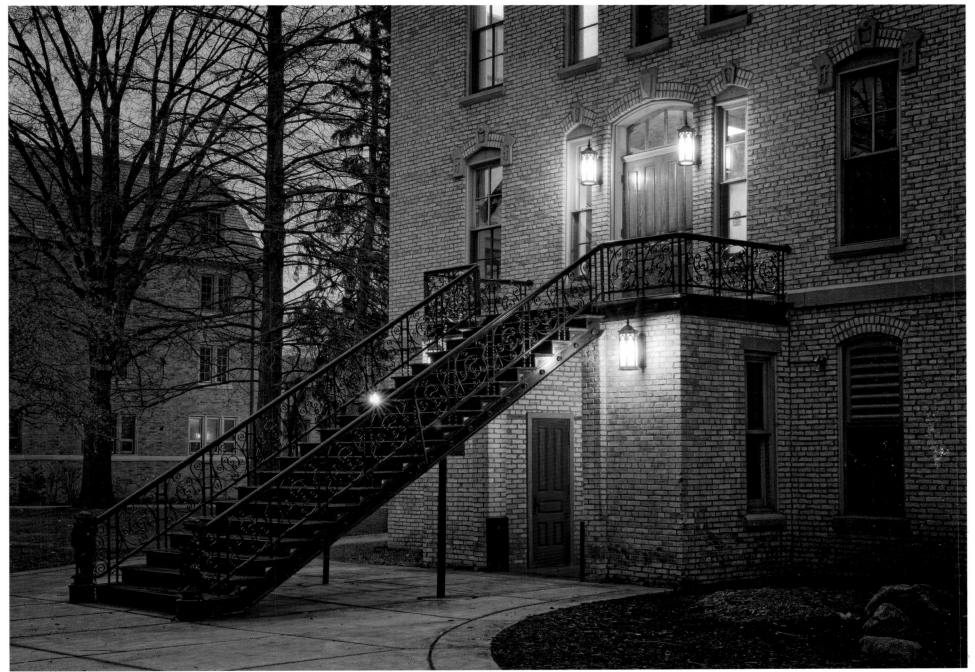

Pre-dawn light casts a warm glow on the steps behind Washington Hall.

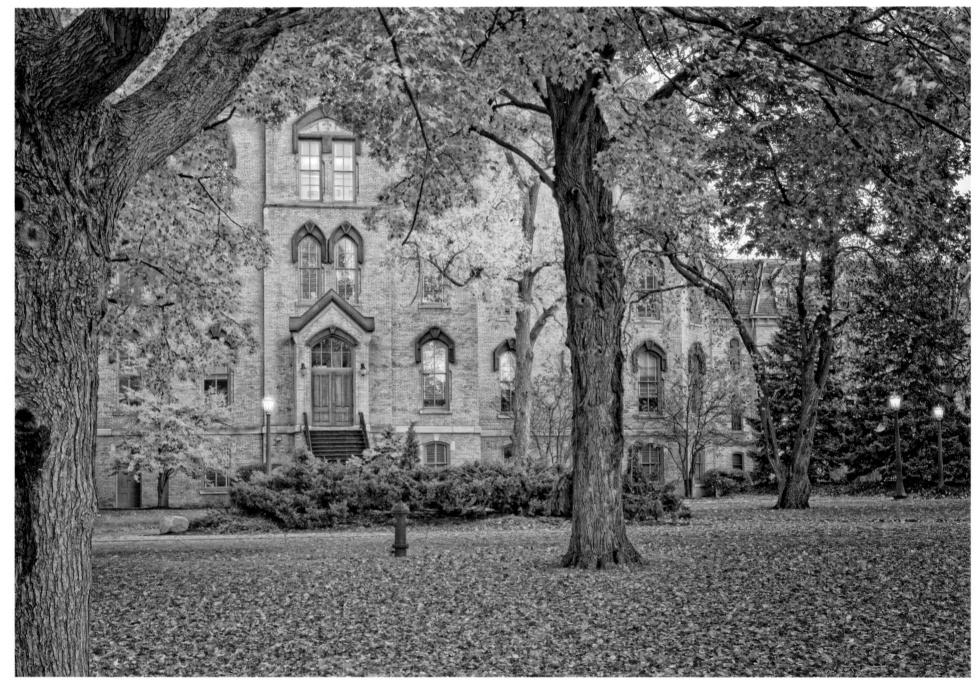

Fall brings a special atmosphere and a colorful blanket of leaves to the campus.

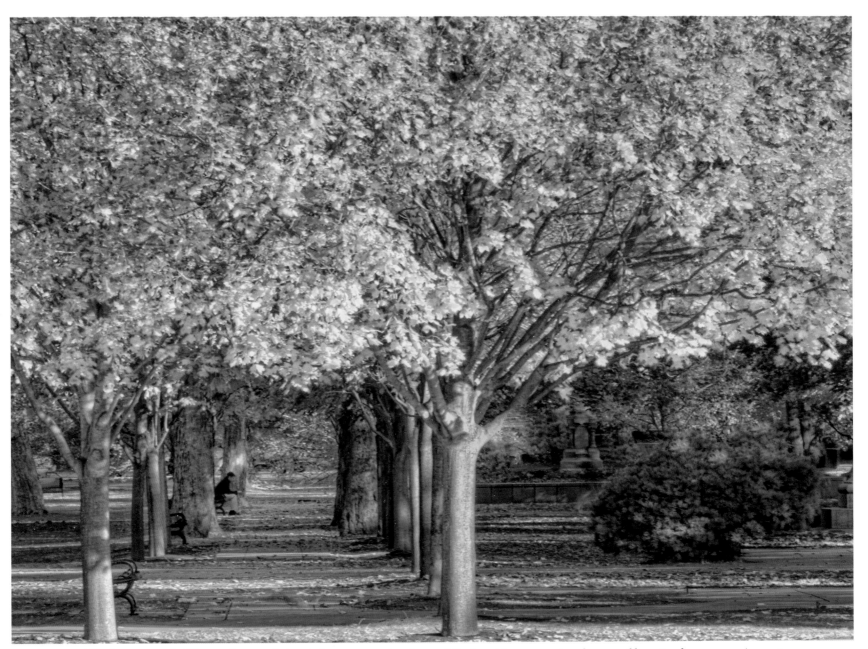

The leaves turn brilliant colors, and the air becomes cool, crisp and fresh, with an occasional scent of burning leaves creeping onto campus from nearby farms. Sidewalks become cushioned by leaves; benches invite a pause and a moment or two for reflection. Football is in the air, and midterms are not far away.

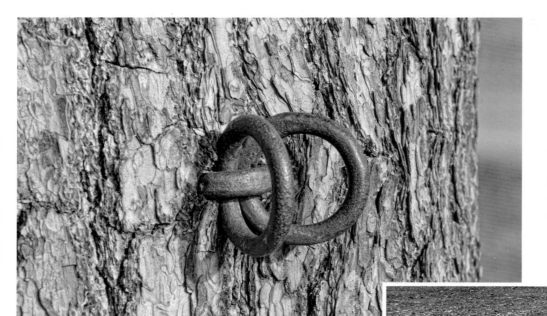

An otherwise unremarkable tree in the God Quad has embedded in its side a pair of hitching rings—remnants of the days when travel to the campus was by horse.

Dr. Emil T. Hofman's "field office" is located alongside the sidewalk that runs between the Main Building and LaFortune Student Center. An iconic figure in the Chemistry department, Dr. Hofman taught children of his earlier students,

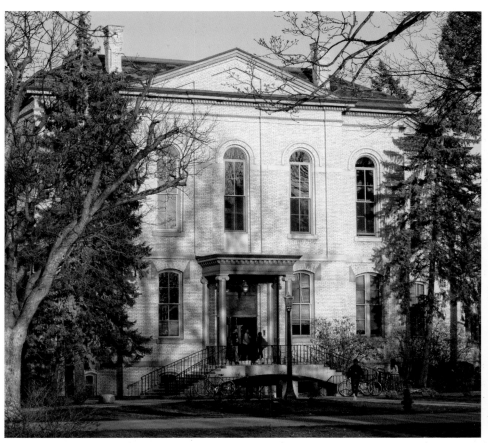

LaFortune Student Center still houses the Huddle, the campus snack bar. The Huddle has evolved from a simple soda fountain with a hamburger grill to an elaborate fast-food complex with expanded seating, a lounge area, wide-screen TVs, and shops.

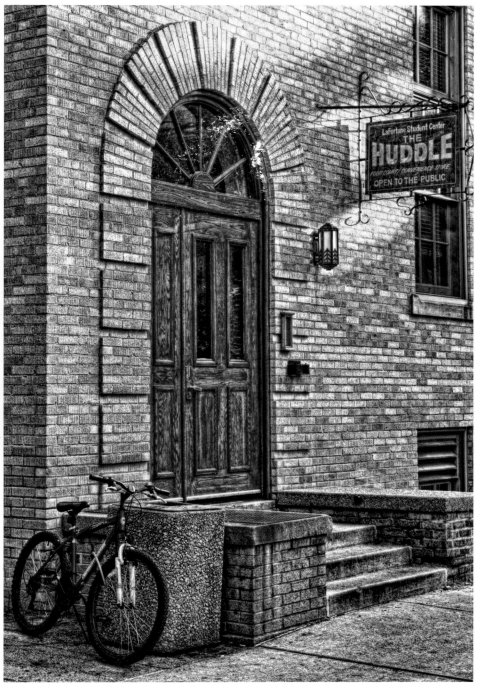

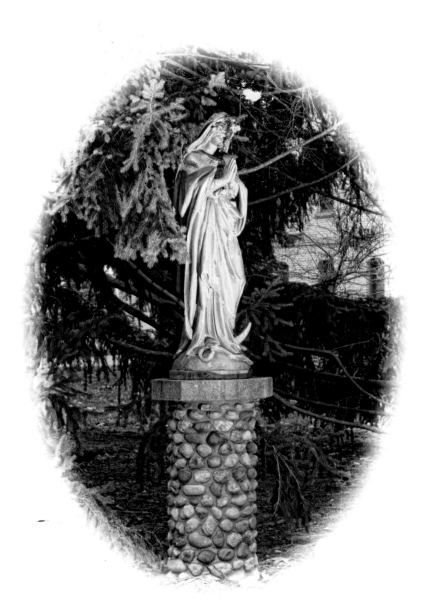

A statue of the Blessed Mother stands in the small courtyard between Cavanaugh and Zahm Halls.

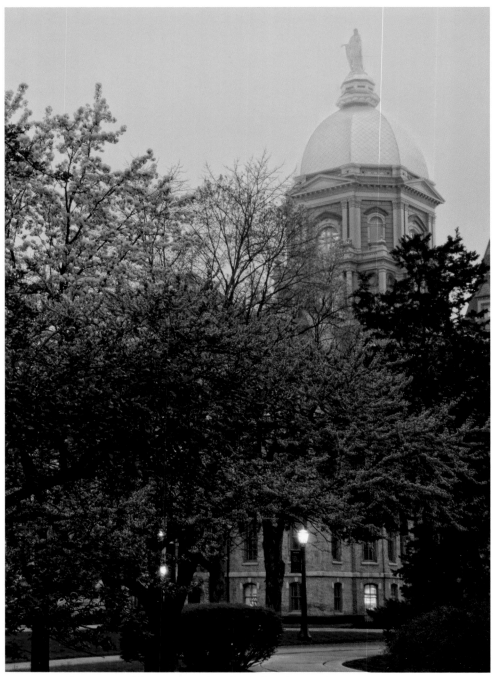

Springtime blossoms in the God Quad complement the Golden Dome and fill the air with a rich fragrance.

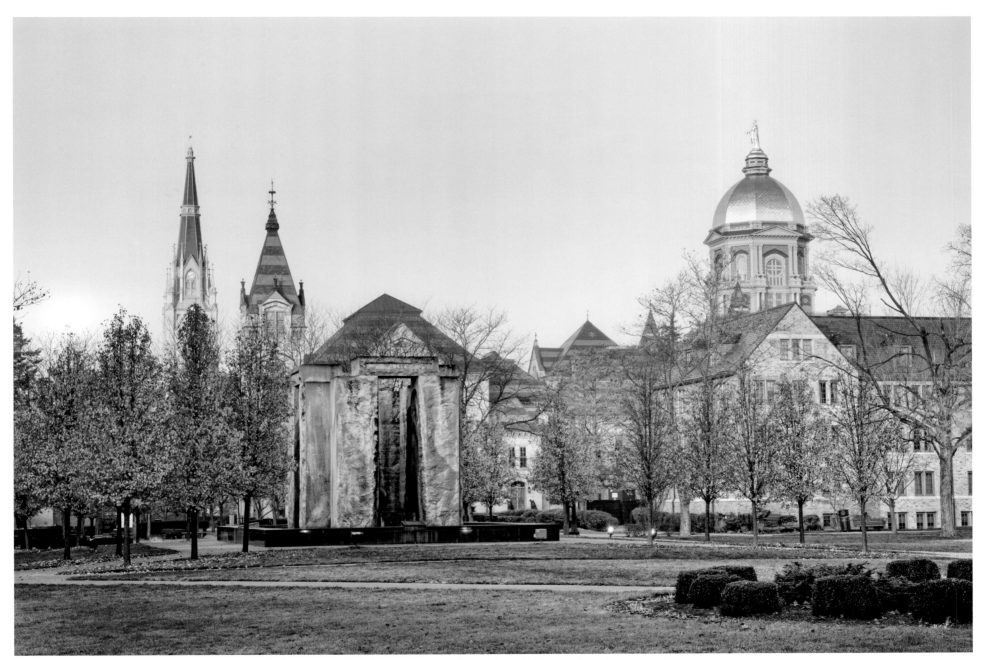

Early morning light in autumn transforms the buildings and the beauty of the campus.

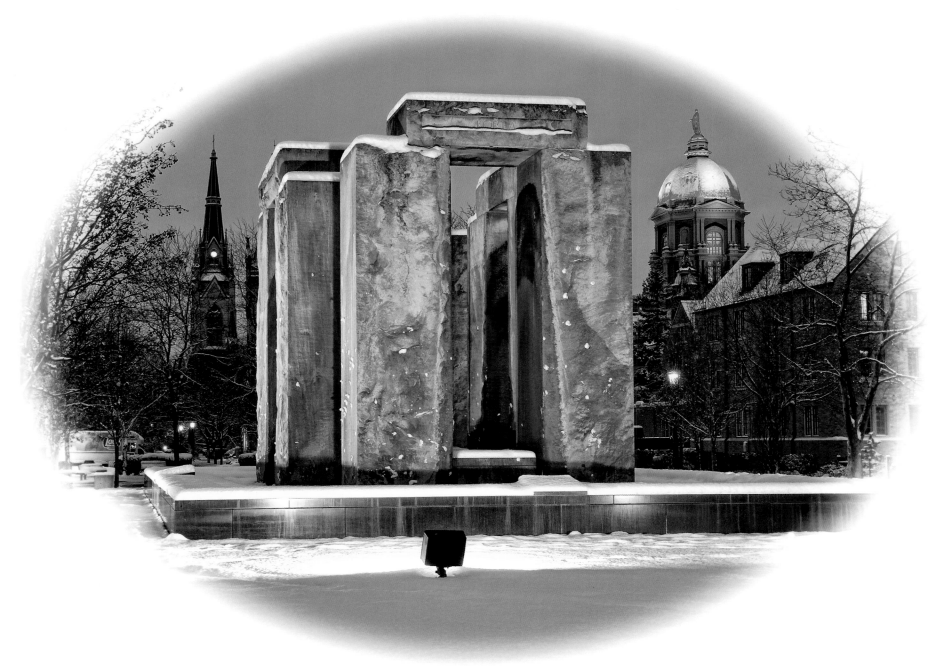

The Basilica of the Sacred Heart, Clarke Memorial Fountain, and the Golden Dome, at the crack of dawn in December.

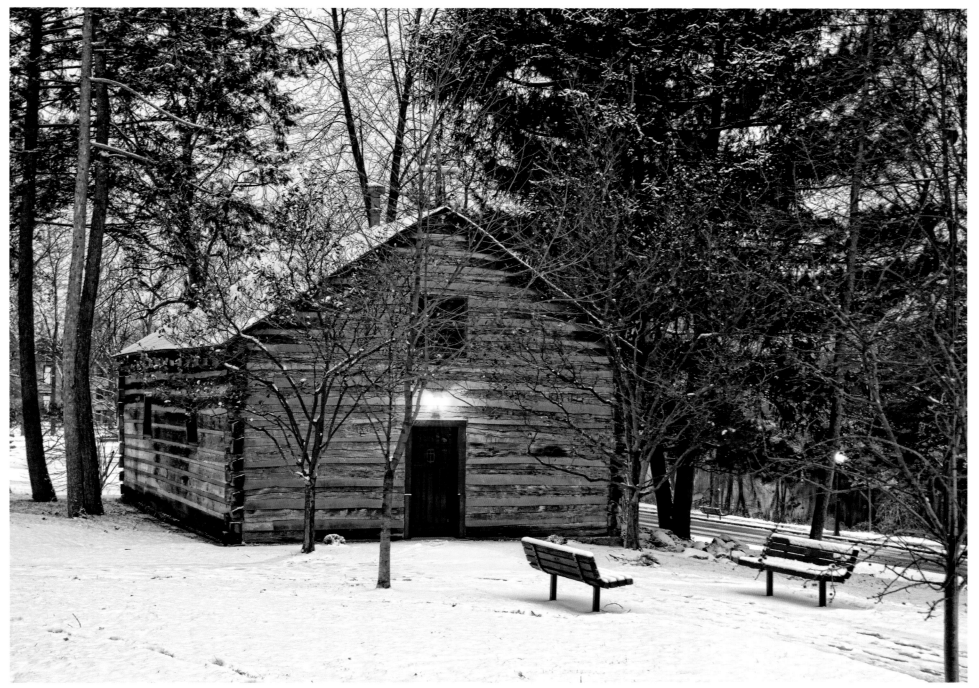
A replica of the Log Chapel built by Fr. Stephen Badin, C.S.C., frequently a site of Masses, weddings, baptisms, and solemnization of engagements.

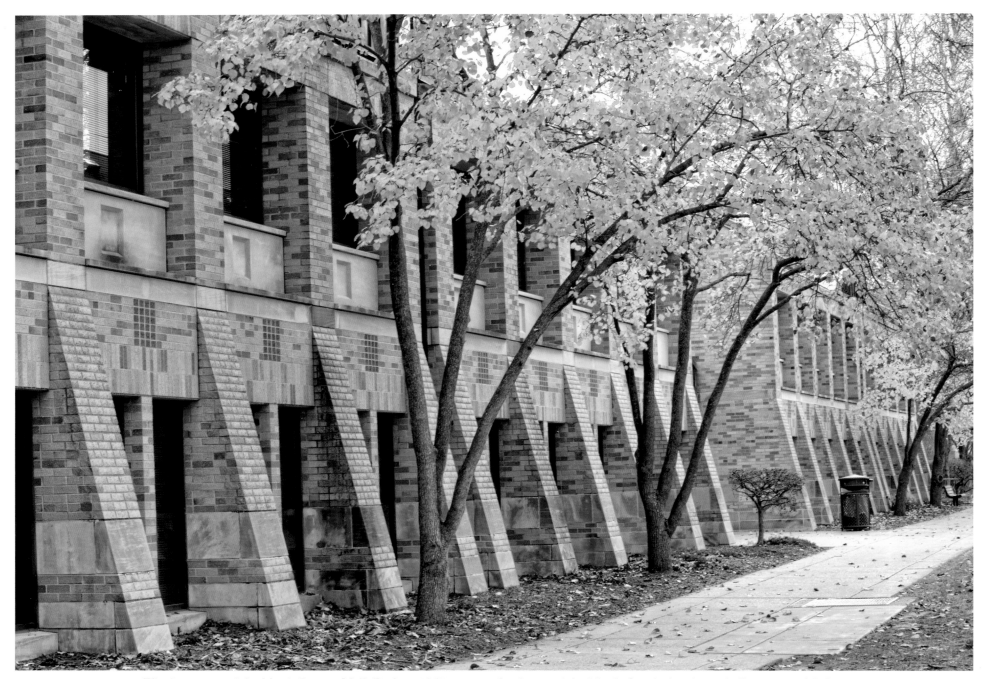

The buttresses of the North Dining Hall. Built in 1957 to serve the dorms of the North Quad, this dining hall was remodeled in 1987 with the addition of a balcony-level dining area. It has Ivan Mestrovic's wood relief of the Last Supper.

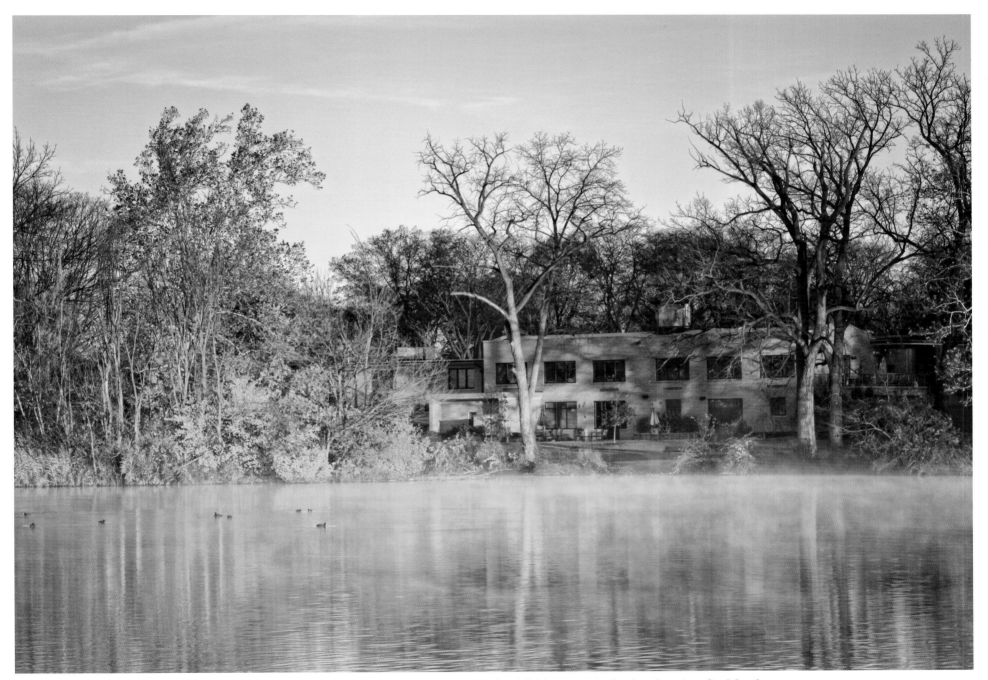

A retirement home for Holy Cross priests sits amidst fall foliage on the banks of a misty St. Mary's Lake. The building was once the Fatima Retreat Center.

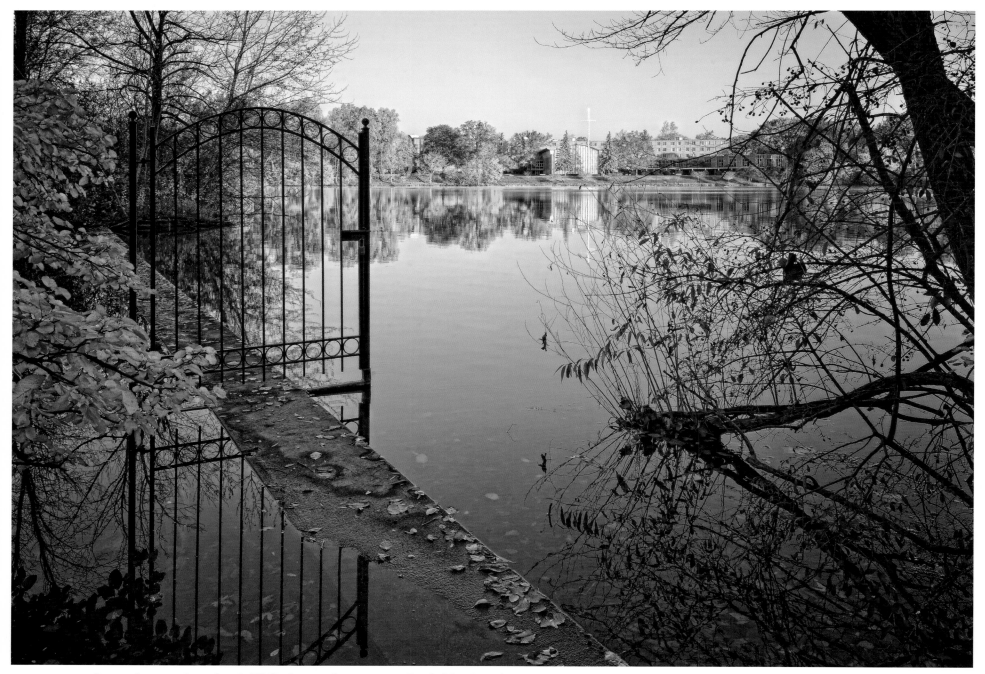

Located across from Lewis Hall, the gated entrance to Duck Island on St. Joseph's Lake holds a particular mystique. The chapel at Moreau Seminary gleams in the background across the lake.

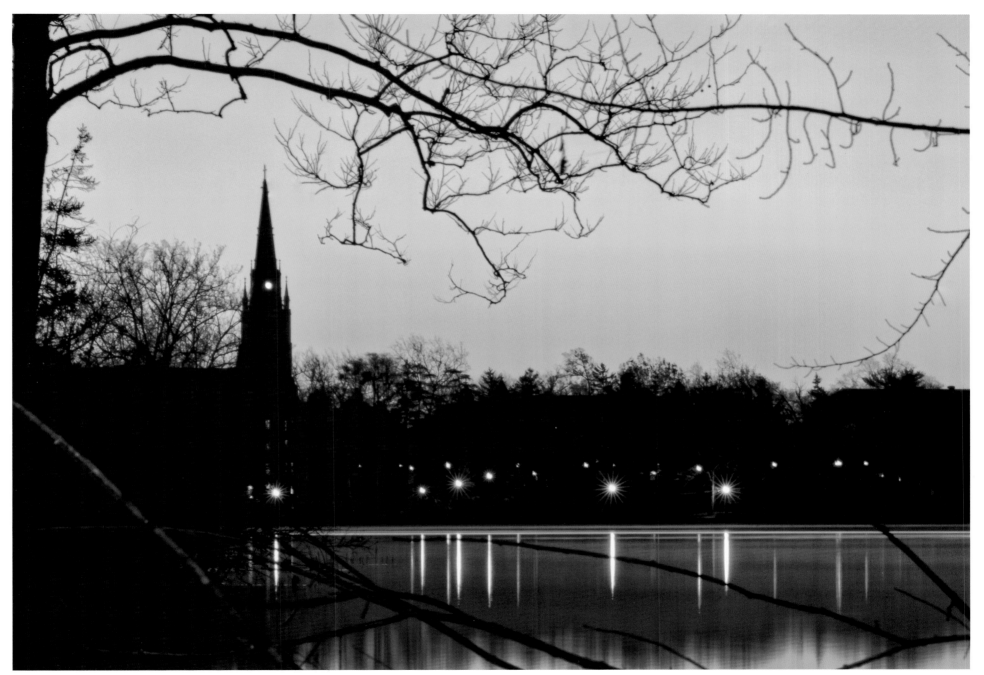

A silhouette of the Basilica of the Sacred Heart at dawn.

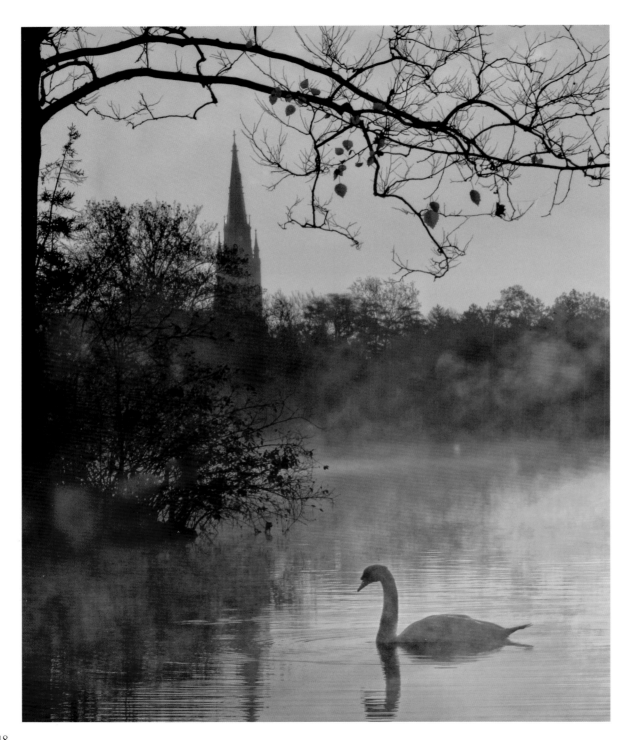

Out of nowhere, a swan graces the already beautiful scene of the Basilica of the Sacred Heart at sunrise, with mist rising from St. Mary's Lake.

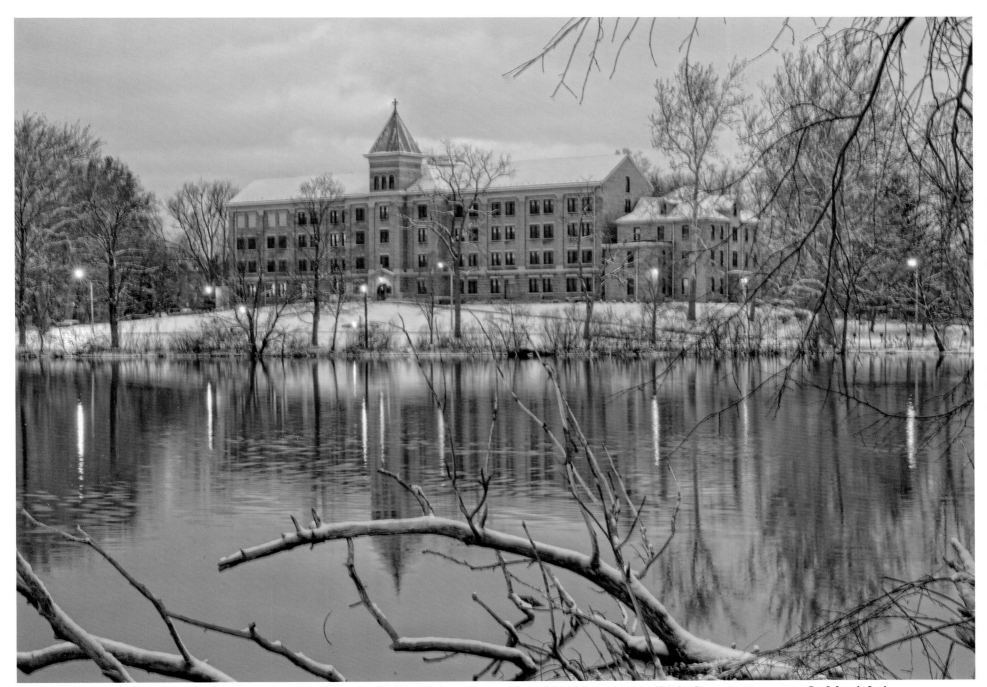

Winter mornings offer an ethereal view of Columba Hall, a residence for brothers of the Congregation of Holy Cross, as seen across St. Mary's Lake.

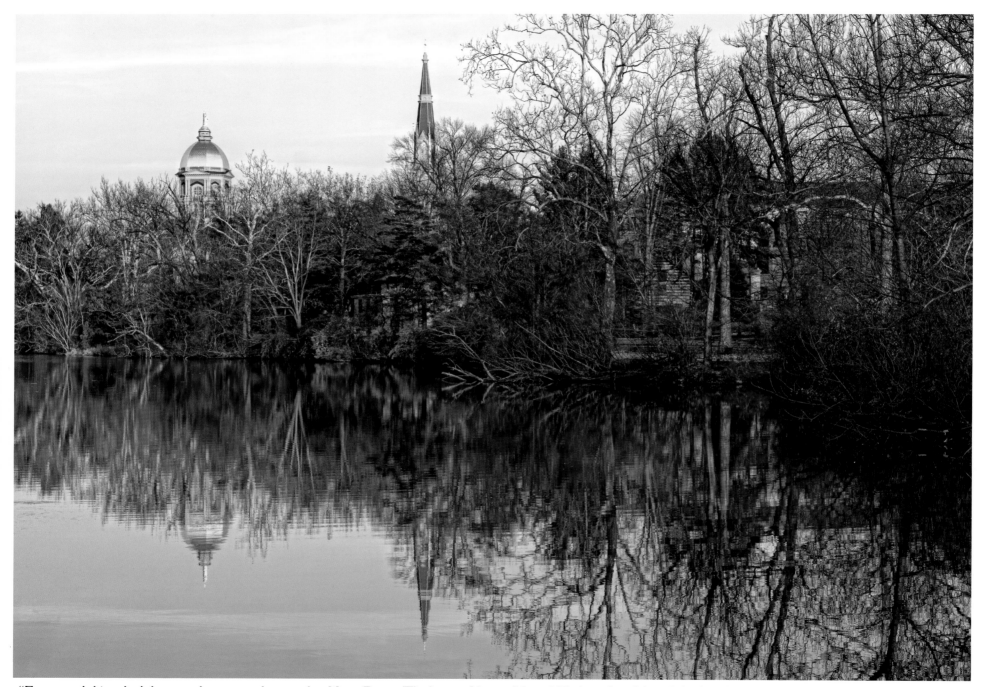

"Every good thing that's happened to me can be traced to Notre Dame. The lessons I learned from ND shaped my life and the friends I made are lifelong." – *Thomas Curtin, '68*

"At a Catholic university we have a special challenge to make sure that the door between the life of the mind and the life of the spirit is kept wide open."
– Former Notre Dame Provost Timothy O'Meara

A statue of Christ overlooks St. Joseph's Lake from a vantage point atop St. Joseph's Hall.

Don't most students at some time in their four years on campus run or walk around the lakes? Wasn't the path covered with a soft blanket of leaves?

Boathouse at St. Joe's Lake (top) and Moreau Seminary framed by a sailboat (bottom).

Sidewalks covered with crunchy ice lead the way along Notre Dame Avenue to the campus and its classrooms and dorms. Winters at Notre Dame can be harsh, with seemingly endless days and nights of punishing cold and blowing snow. Snowplows speed through the night, banging into sidewalk edges and scraping away the comfort of sleep.

Notre Dame's campus is rich in symbols: statues, stained glass, and bas-reliefs on buildings. Among them, the sculptures of Ivan Mestrovic provide a life-sized drama of meaning and emotion. Here, Christ encounters, invites, and enlivens the Samaritan woman at Jacob's well, near O'Shaughnessy Hall. Surrounding benches invite us to pause, recall, and reflect on the unfolding drama of such encounters with Christ in our own lives.

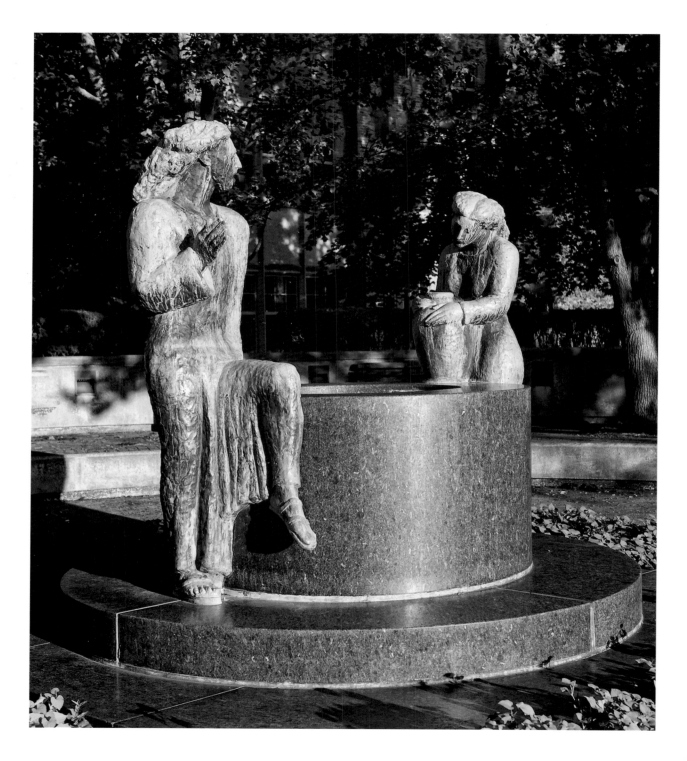

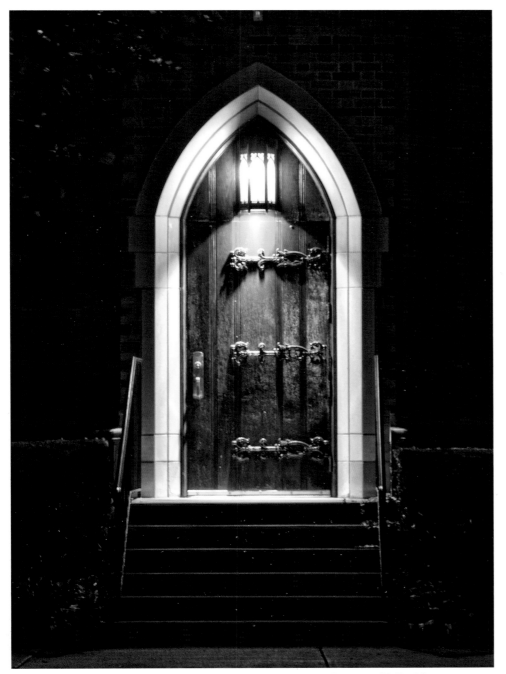

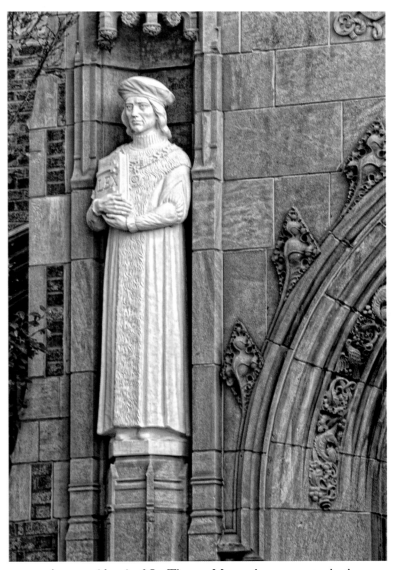

A statue (above) of St. Thomas More, who was put to death for refusing to surrender his principles or his integrity, graces an entrance at the west side of the Biolchini Hall of Law.

In the wee hours of the morning, a door (left) to the Biolchini Hall of Law appears to be an entrance to a castle.

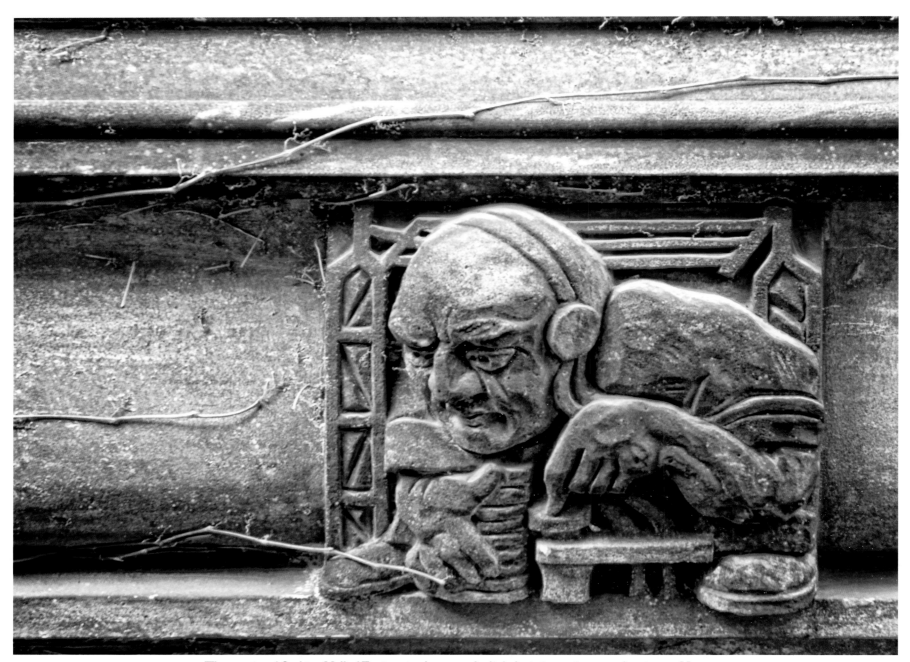

The exterior of Cushing Hall of Engineering has several reliefs depicting caricatures of engineers. Here, with headset squeezing his temples, an (electrical) engineer is shown sending Morse code.

At the South Quad, where brothers of the Congregation of Holy Cross once sorted mail, the re-purposed former Post Office serves as the meeting place for the campus council of the Knights of Columbus.

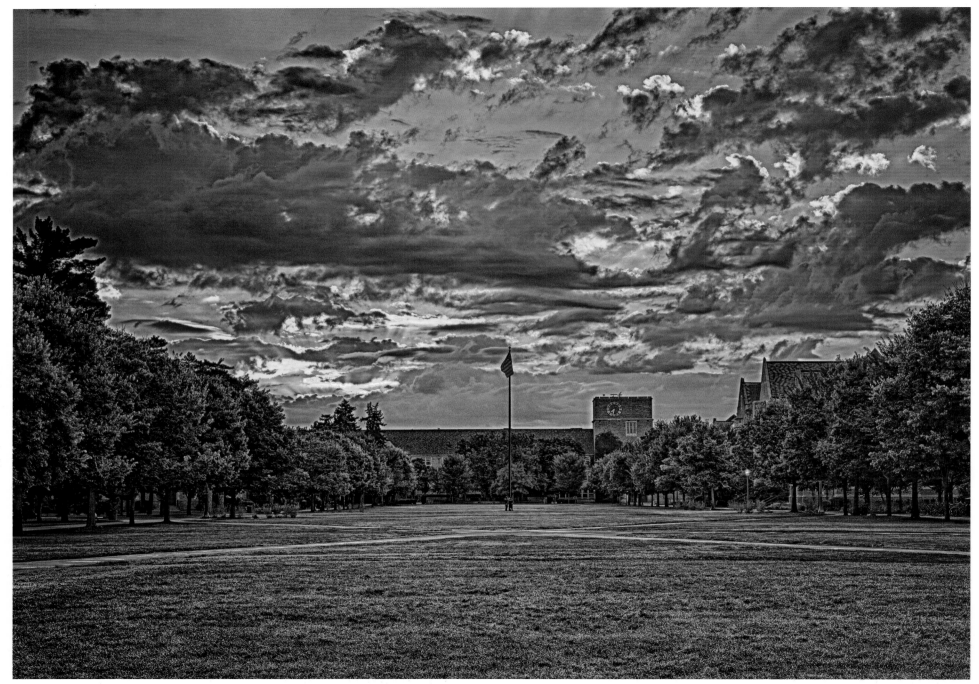

O'Shaughnessy Hall and flag-raising in the Main Quad at sunrise.

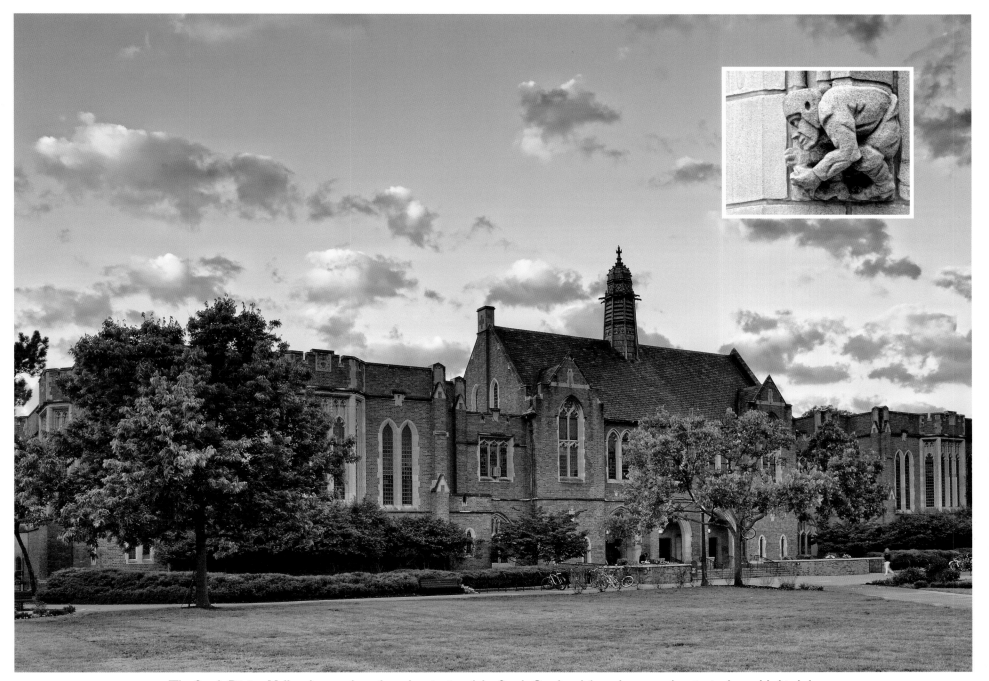

The South Dining Hall gathers students from dormitories of the South Quad and from the newer dormitories located behind the Morris Inn. The two side entrances to the dining hall are embellished with '30s-era reliefs of cartoonish figures of athletes (insert).

Christmas wreathes decorate the campus as the holy season of Advent reminds us
that the end of the fall semester is approaching, and bringing with it final exams.

Sorin Hall occupies a prominent place geographically and socially at Notre Dame. "The mystique of Notre Dame, that seemingly incomprehensible measure of loyalty and devotion to the university that characterizes so many of our graduates and friends, is best explained through the on-campus living experience of the students... The residence halls are places where values are clarified, friendships are formed, and faith is tested and professed. There is nothing to replace simply being here through the cycles of the seasons and years." – Fr. Edward A. Malloy, C.S.C., President Emeritus and longtime resident of Sorin Hall

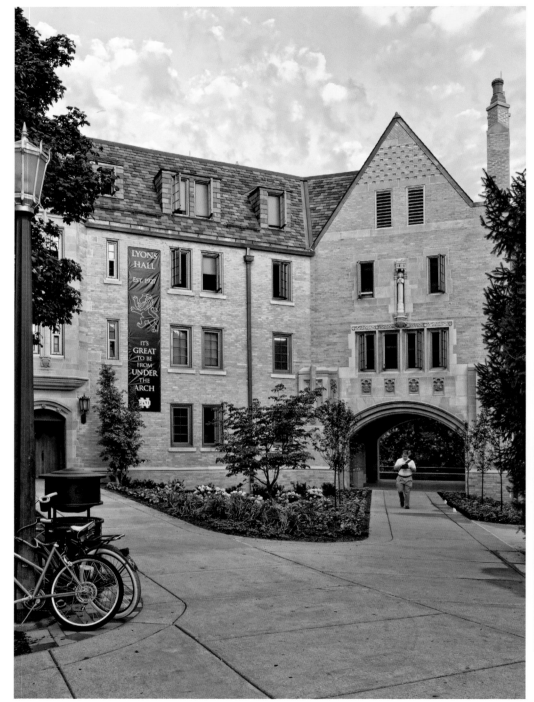

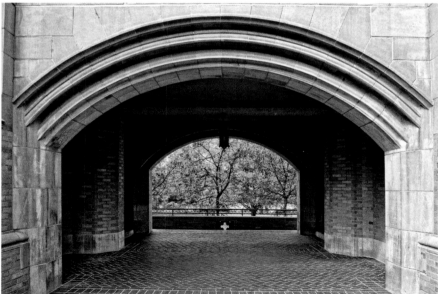

Lyons Hall is decorated with statues and numerous reliefs. Its arch provides an iconic view of fall foliage near St. Mary's Lake. Campus lore associates tales of romance with the plaza under the arch.

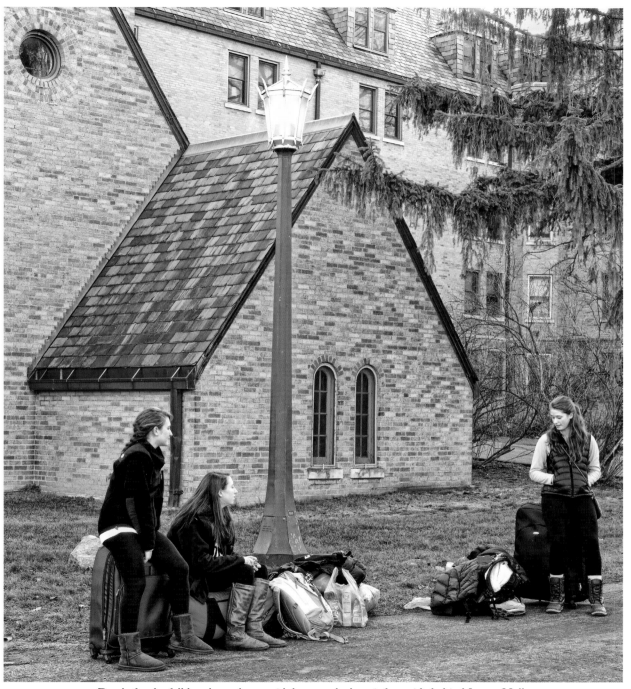

Ready for the fall break, students, with bags packed, wait for a ride behind Lyons Hall.

Badin Hall, built in 1897 and named after Rev. Stephen Badin who donated the land for the original Log Chapel, now has the distinction of being the smallest women's dorm on campus.

O'Neil Hall typifies the modern dormitories built on land once occupied by the Burke Memorial Golf Course.

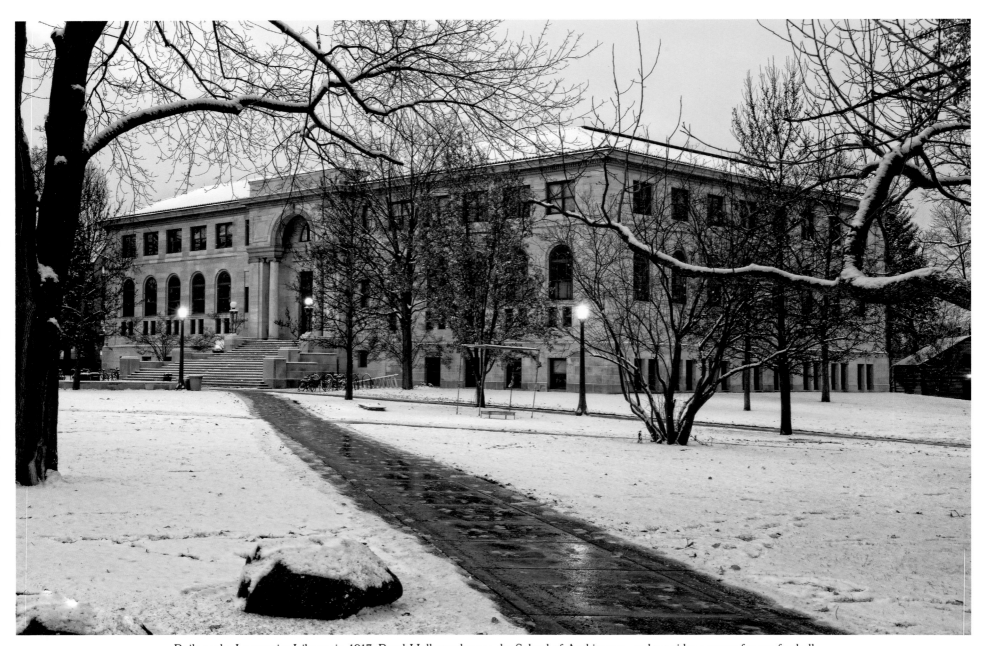

Built as the Lemonnier Library in 1917, Bond Hall now houses the School of Architecture and provides a venue for pre-football game performances by the marching band, and a stepping-off point for its march to the stadium. Older alums will recall that the former library was one of only a few places available for studying before an exam.

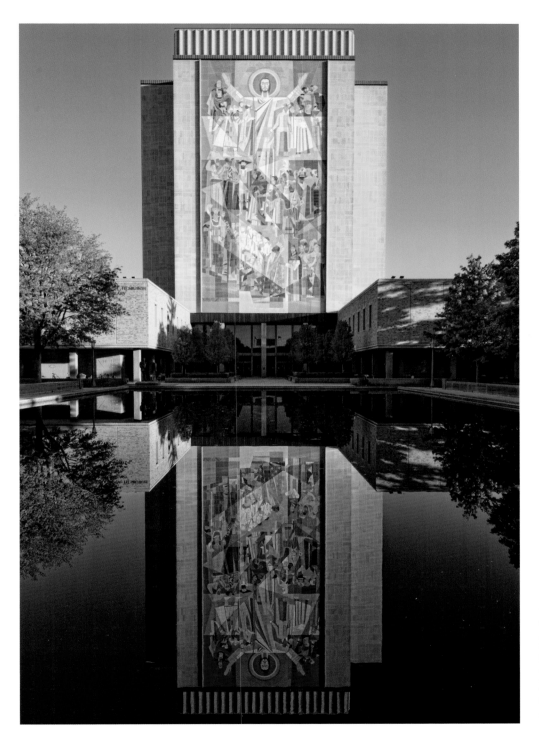

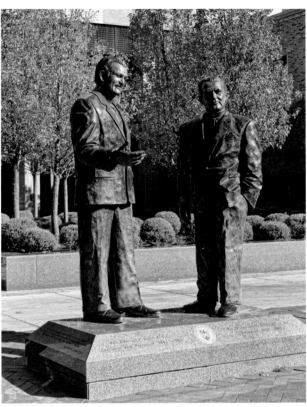

Two bronze statues—one of Rev. Edmund P. Joyce, C.S.C. and the other of Rev. Theodore M. Hesburgh, C.S.C.—greet us at the plaza of the Hesburgh Memorial Library. Together they served the University as Executive Vice President and President, respectively, for 35 years.

The Fieldhouse, Navy Drill Hall, Vetville, the radio station, and Cartier Field have all vanished in the modern era of the campus. The transition began with the construction of the Hesburgh Memorial Library, which opened for the fall semester in 1963 on the former site of Cartier Field.

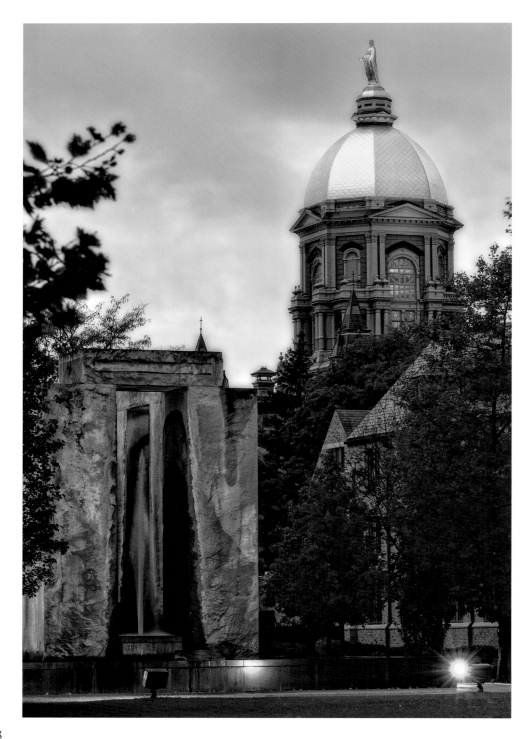

"The unique interplay between clouds, light and the Golden Dome presents a rich and ever-changing feast of images, here from a vantage point near the library. My portfolio of images of the campus is dominated by my attraction to the beauty of the Golden Dome, and its reminder of Notre Dame's place in my heart." – *M. D. Ciletti, '64, '65, '68*

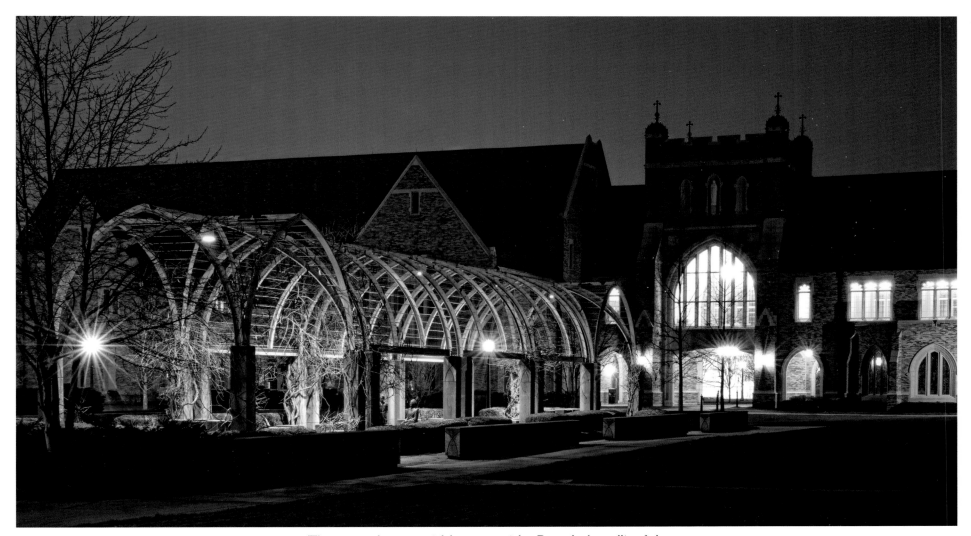

The campus has a special beauty at night. Beneath the trellis of the Sesquicentennial Common near the Eck Hall of Law, visitors will find a bronze statue of Christ announcing the Good News to peasant children.

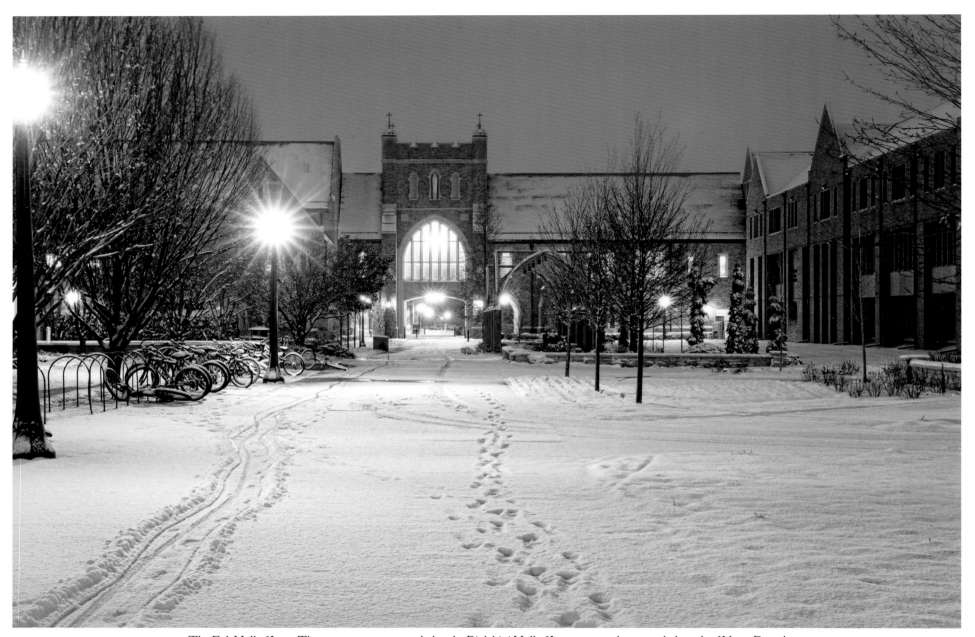

The Eck Hall of Law. The structure was appended to the Biolchini Hall of Law to serve the expanded needs of Notre Dame's prestigious law school. On football Saturdays the marching band passes through the arch on its way to the stadium.

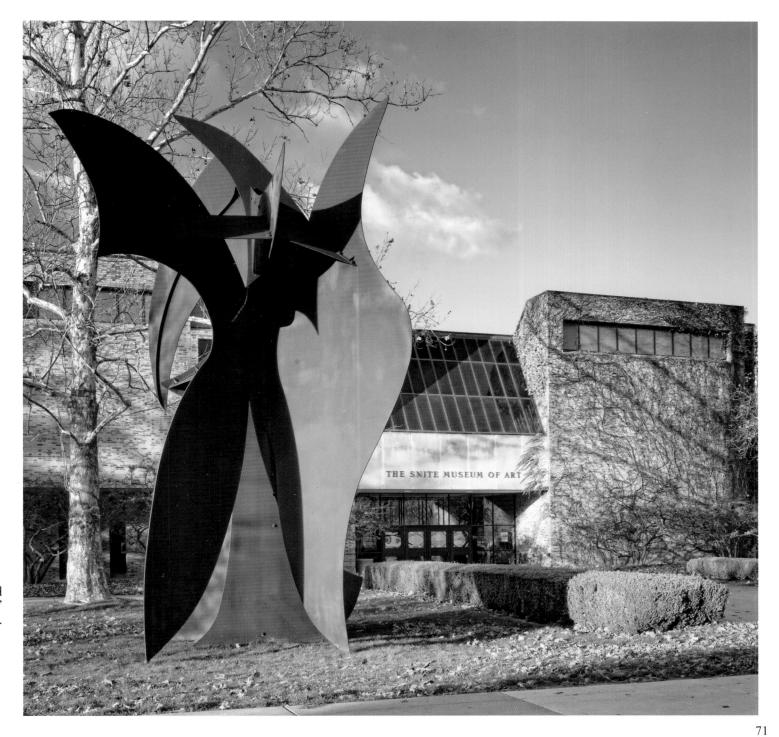

Golden afternoon light shines on David Hayes' ('53) steel sculpture "Griffon" outside the Snite Museum of Art.

71

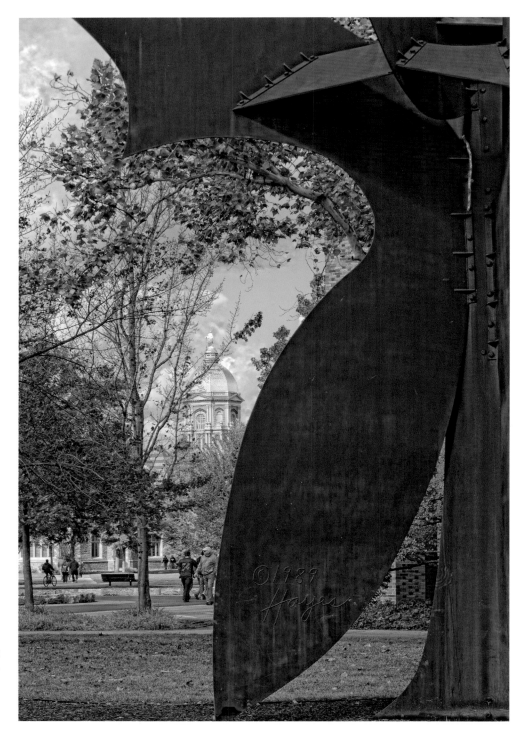

Next to "Griffon" at the Snite Museum
of Art, one gets a view of the Dome.

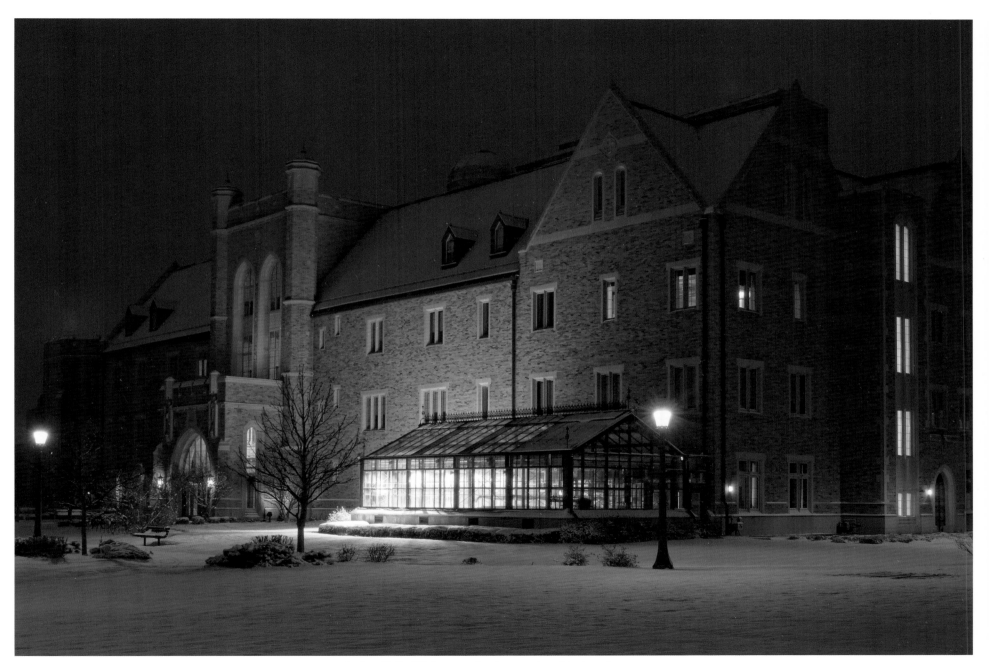

Jordan Hall of Science eerily glows under a blanket of snow.

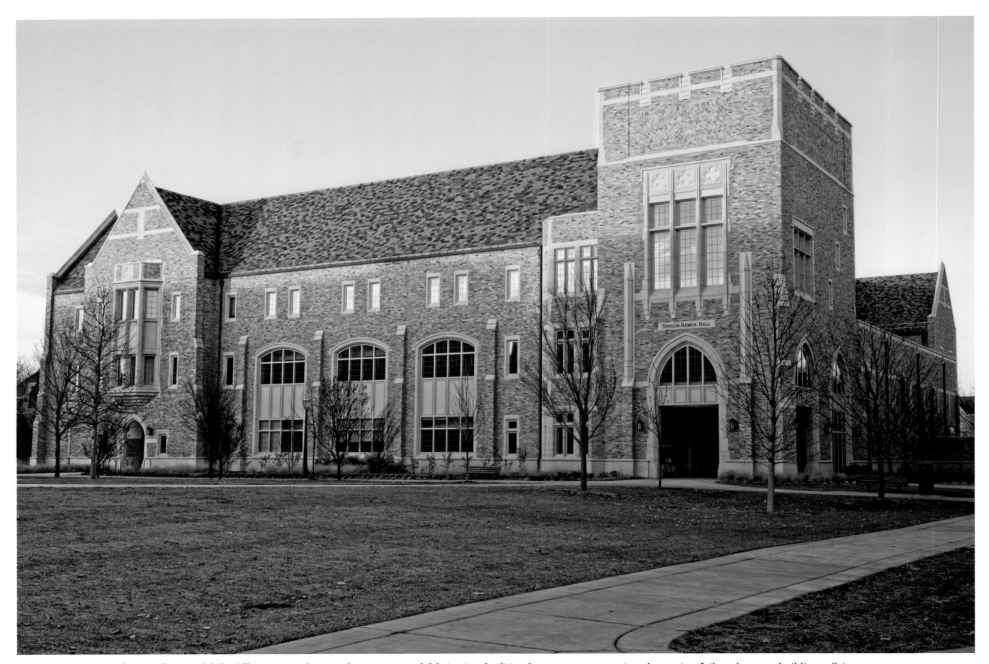

Stinson-Remick Hall of Engineering houses clean rooms and fabrication facilities for nanostructure microelectronics. Like other new buildings, Stinson-Remick blends with the architectural legacy of the campus. Its chapel honors Blessed Basil Moreau, founder of the Congregation of Holy Cross.

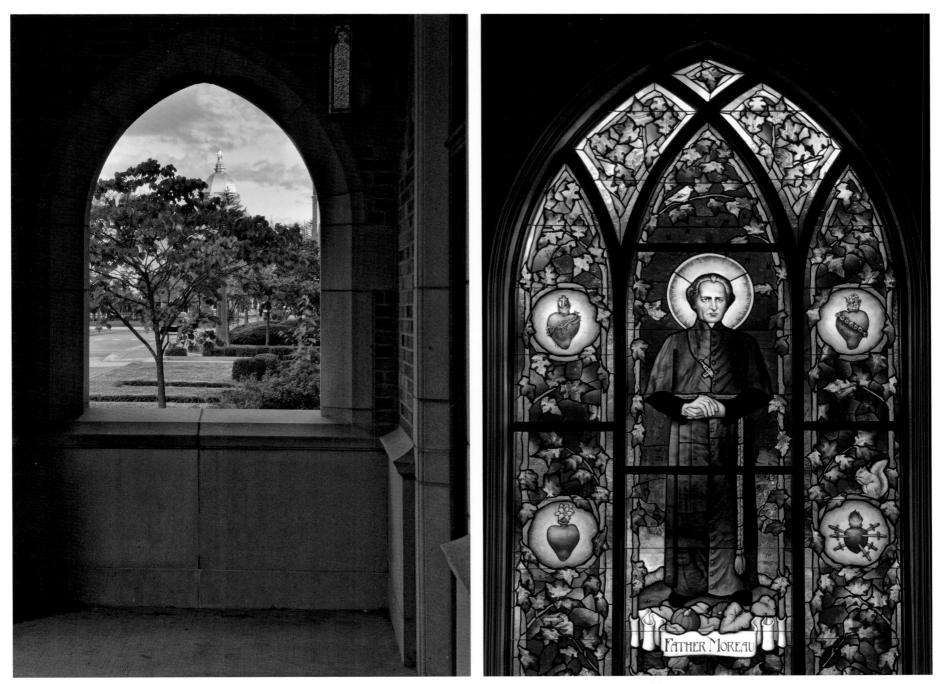

Stained-glass window of Blessed Basil Moreau in the chapel of Stinson-Remick Hall.

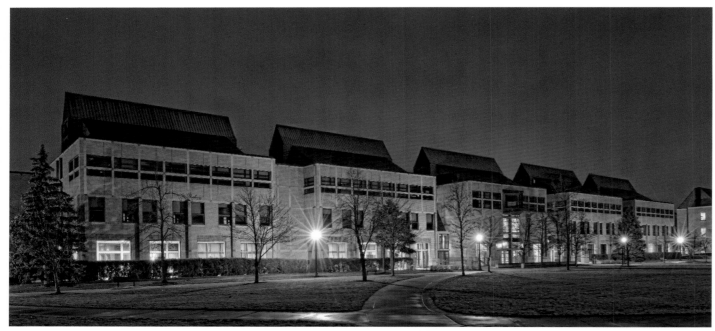

When built in 1992, DeBartolo Hall
(left), which is longer than a football
field, doubled Notre Dame's classroom
space, providing classrooms, offices,
seminar rooms, lounges, and lecture
halls. Mendoza Hall (below) houses the
College of Business.

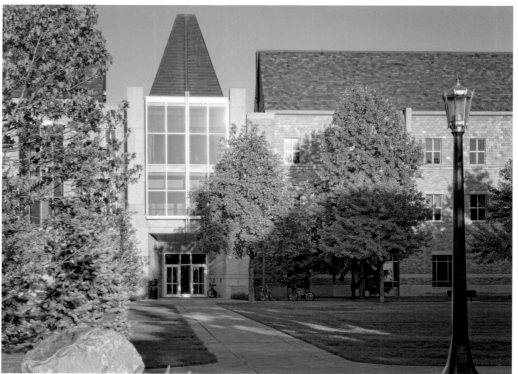

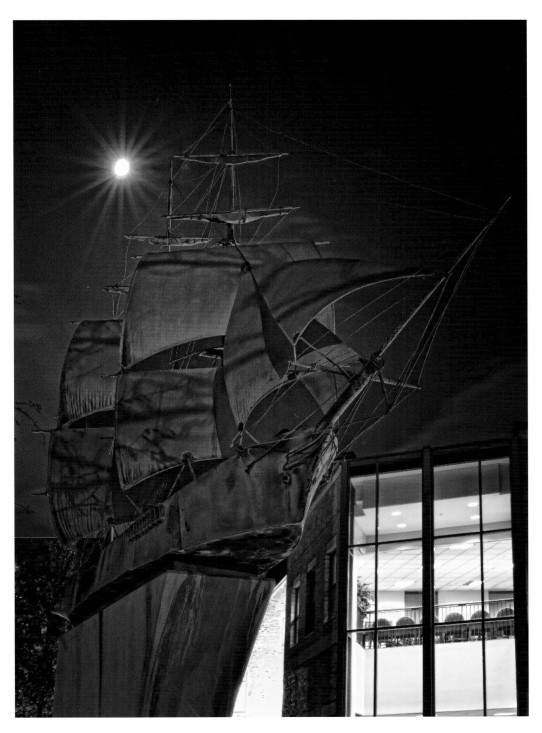

The schooner that sails above the courtyard of the Mendoza College of Business used to sit above the entry of the old Commerce Building (now known as Hurley Hall). A large globe still spins in the lobby of Hurley Hall.

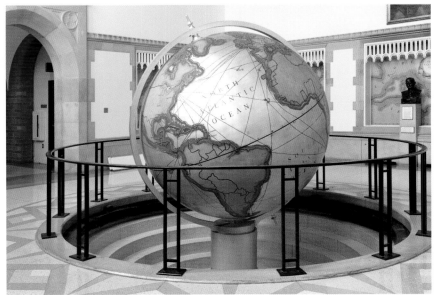

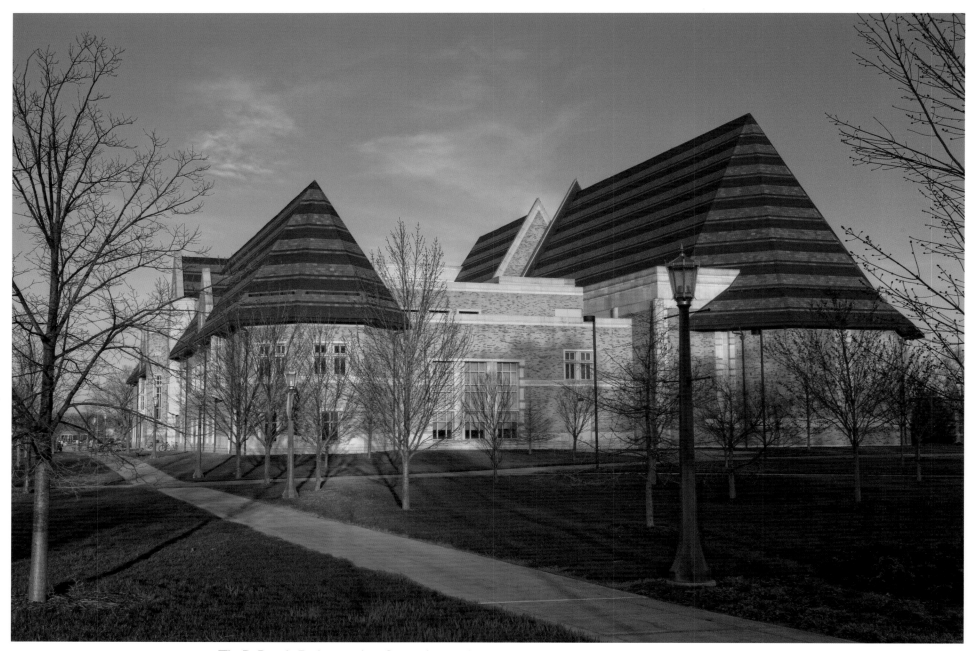

The DeBartolo Performing Arts Center glows as the sun sets in the western sky over Cedar Grove Cemetery.

Students of the '60s will recall that radio station WNDU signed off at night with a recording of Fr. Hesburgh reciting the prayer of St. Francis: "Oh Lord, make me an instrument of your peace...." Today, the Hesburgh Center for International Studies provides a home for the Kroc Institute for International Peace Studies and the Kellogg Institute for International Studies.

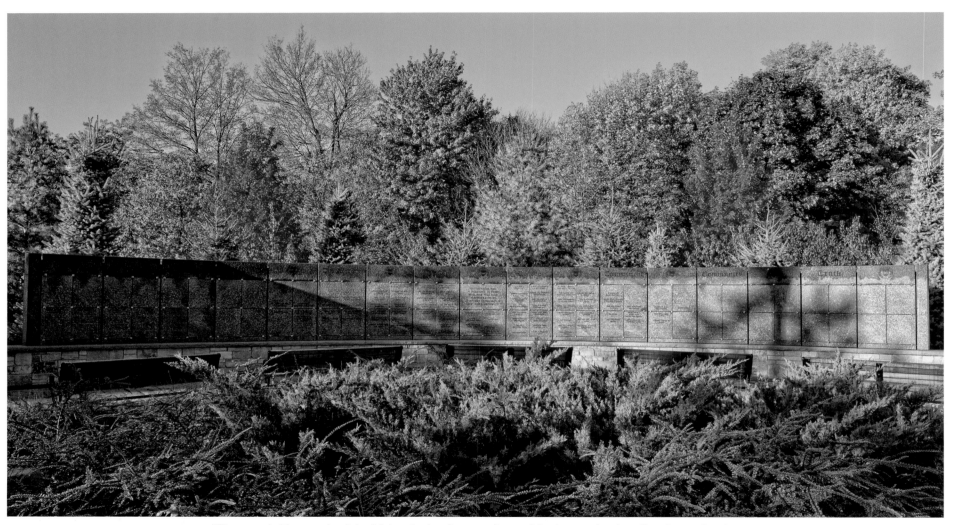

The remarkable growth of the University has been made possible, in part, by the gifts of several major benefactors. A wall near the west side of the DeBartolo Performing Arts Center honors their generosity.

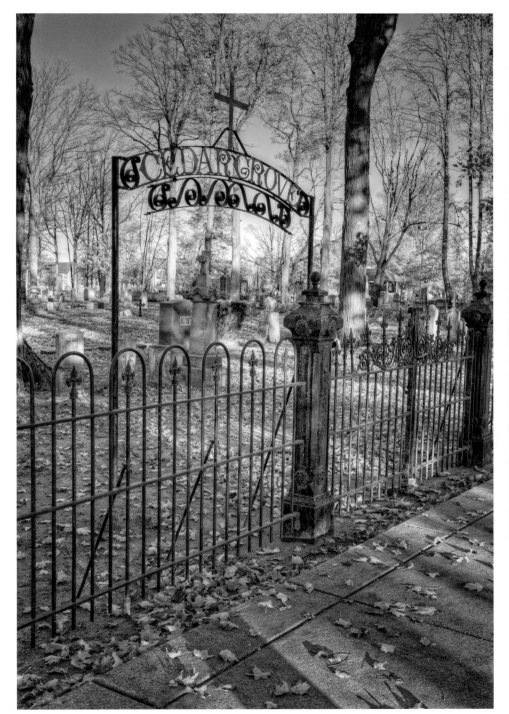

A short walk down Notre Dame Avenue leads to Cedar Grove Cemetery, the final resting place for some of Notre Dame's faculty, athletes, students, benefactors, and war heroes, along with residents of South Bend.

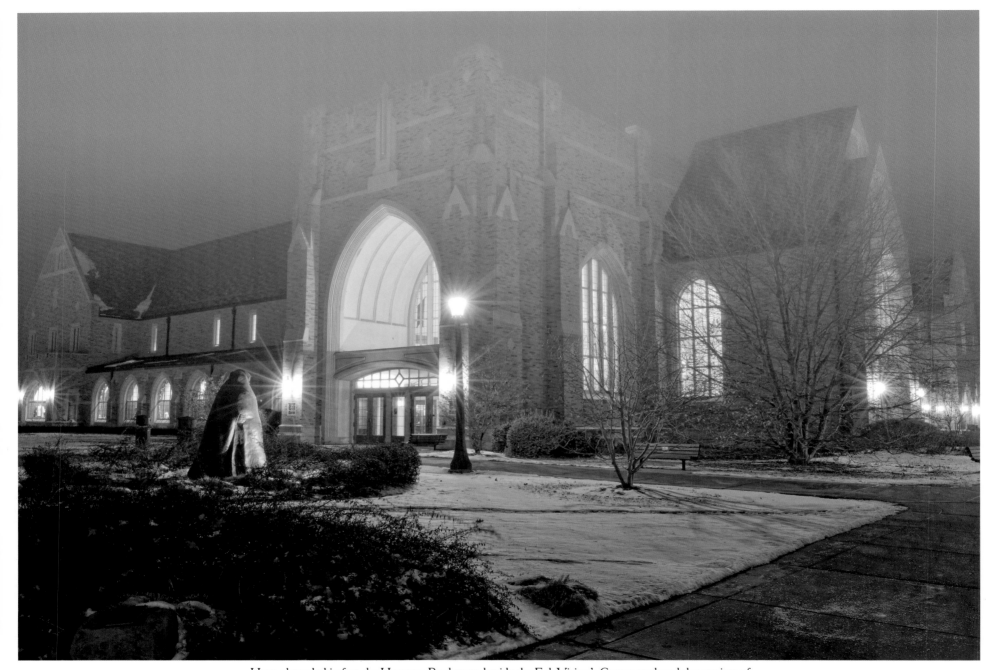

Here, shrouded in fog, the Hammes Bookstore, beside the Eck Visitor's Center, replaced the services of the former bookstore and men's clothing store that once stood next to Badin Hall in the South Quad.

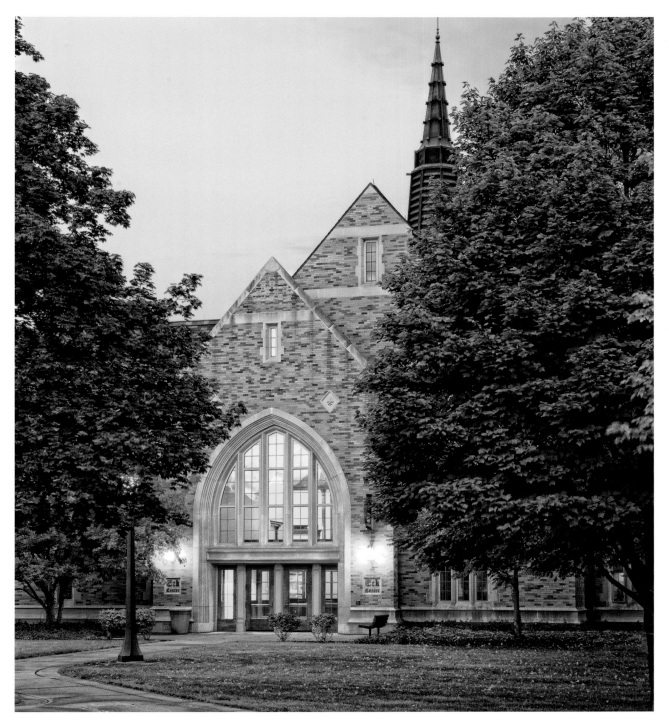

The Eck Center, located prominently on Notre Dame Avenue, houses the offices of the Alumni Association and a visitor's center.

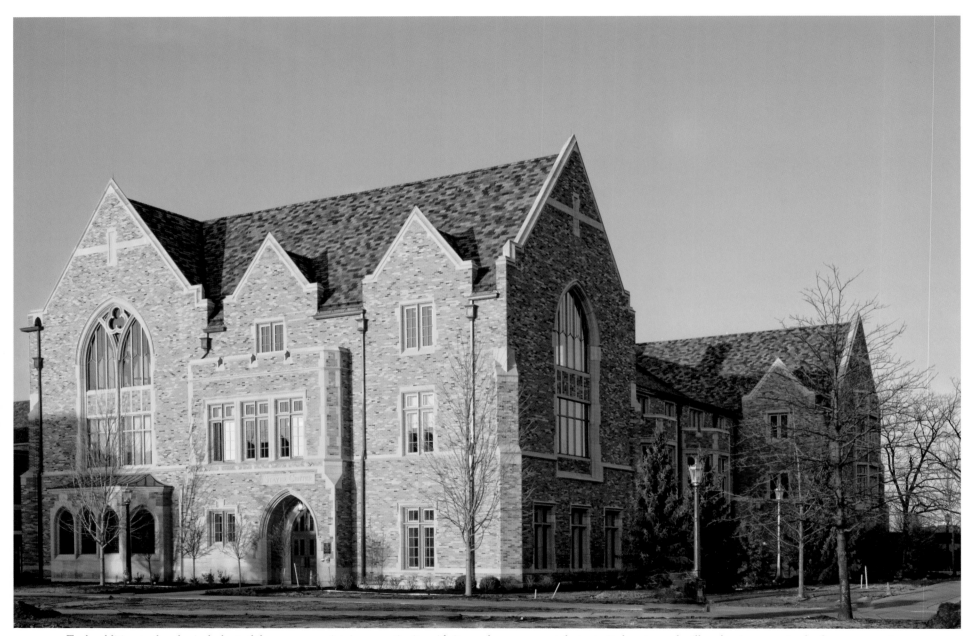

Each addition to the physical plant of the campus maintains a continuity with its predecessors, contributes to its beauty, and will underpin memories for future generations of students. Here, the Stayer Center for Executive Education, built in 2013, anchors the southeast corner of the DeBartolo Quad, with programs tailored to the growth and development of industry leaders.

Fittingly, a stained-glass window in the chapel of the Stayer Center features St. Matthew, the tax collector who was called to ethical behavior by Jesus.

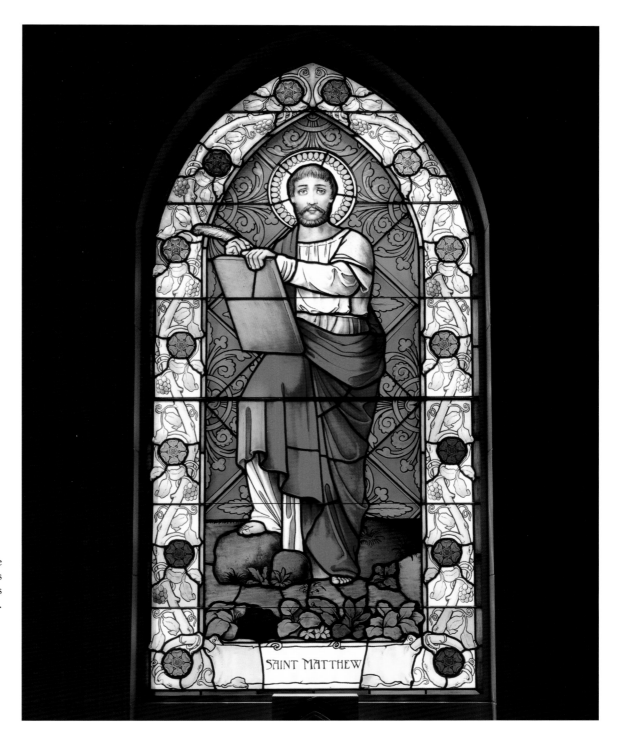

SAINT MATTHEW

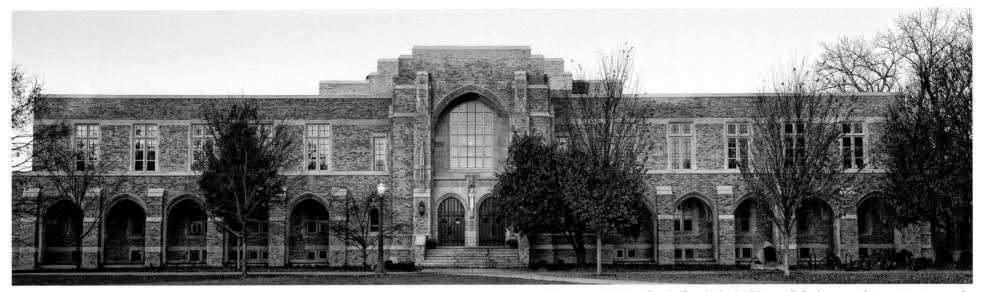

"The Rock." The Rockne Memorial was dedicated in 1937 to honor Coach Knute Rockne. Dominating the west end of the South Quad, the building still finds use with its swimming pool, handball courts, and squash courts. A putting green sits on the south side of the building.

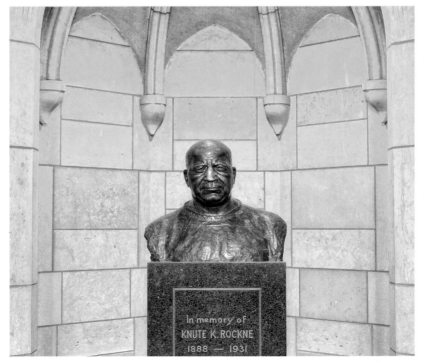

A bust of Knute Rockne in the lobby of the Rockne Memorial has developed a shiny nose—a result of its being rubbed for good luck by admiring fans.

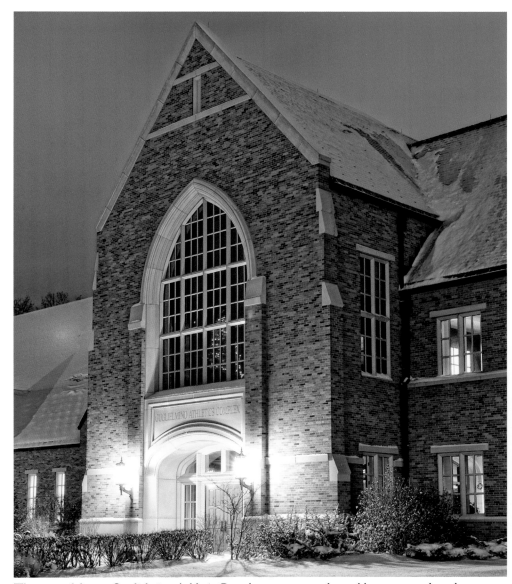

The state-of-the-art Guglielmino Athletic Complex supports student-athletes across a broad spectrum of sports. The facility houses meeting rooms, equipment rooms, locker rooms, a short track (50 yards), exercise pools, and a fitness center with an extensive array of weight-training equipment. This is where aspiring athletes discover the relationship between pain and gain.

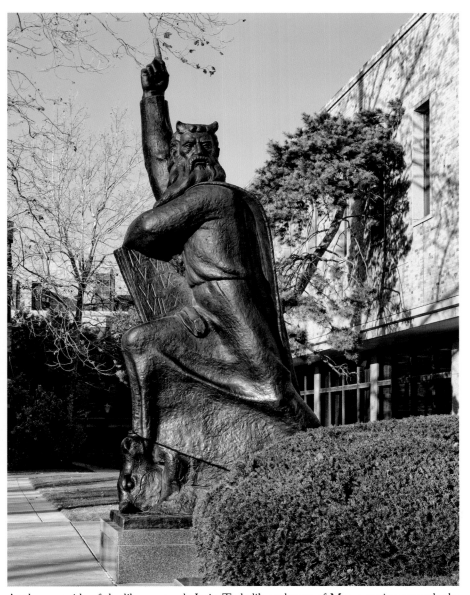

At the west side of the library stands Josip Turkalj's sculpture of Moses gazing towards the football stadium, pointing to the heavens, and holding the Ten Commandments. Among fans of football the sculpture has popular identities, such as "First-Down Moses" and "Number 1 Moses."

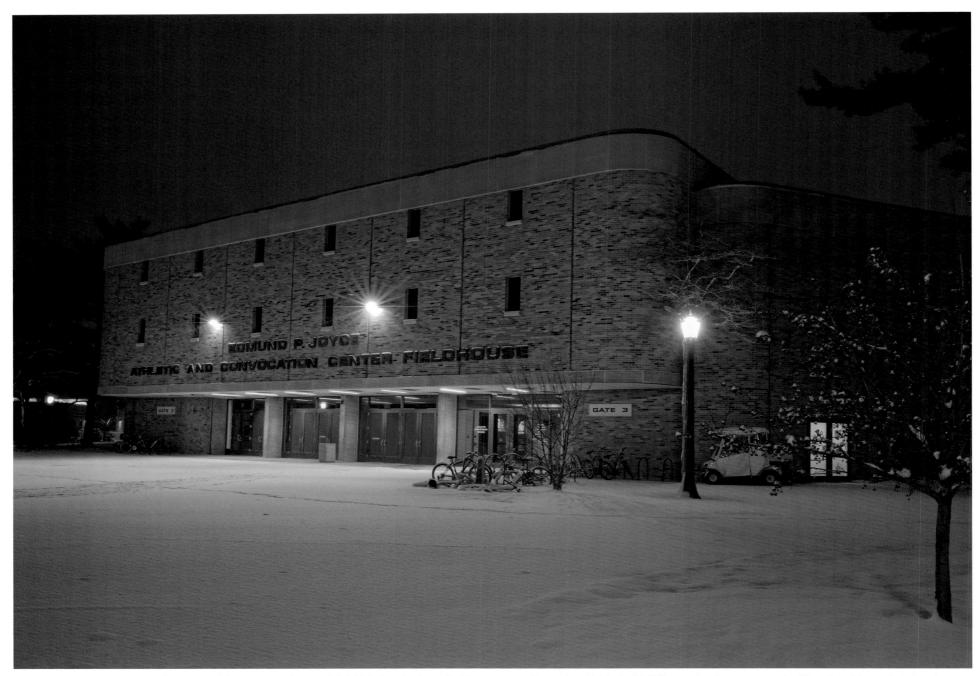

A snowy night at the Joyce Athletic and Convocation Center (JACC) belies this hub of athletic activity. Opened in 1968, the JACC provides the campus with offices for athletic administration, and venues for basketball, fencing, boxing, and volleyball. The basketball arena was the site of Notre Dame's 1974 upset of UCLA, ending that school's 88-game winning streak.

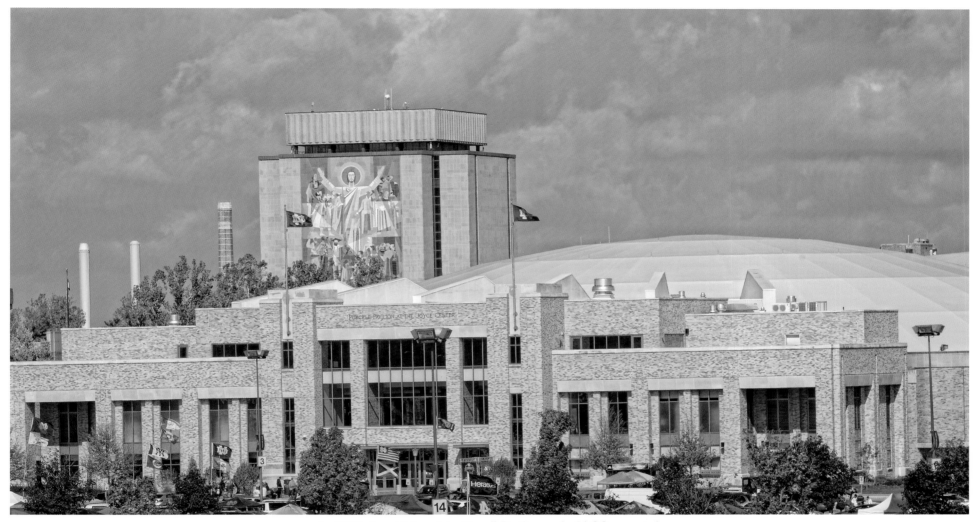

In 2009, the addition of the Purcell Pavilion to the JACC renovated the basketball arena and provided additional amenities increasing the utility of the facility for basketball and women's volleyball.

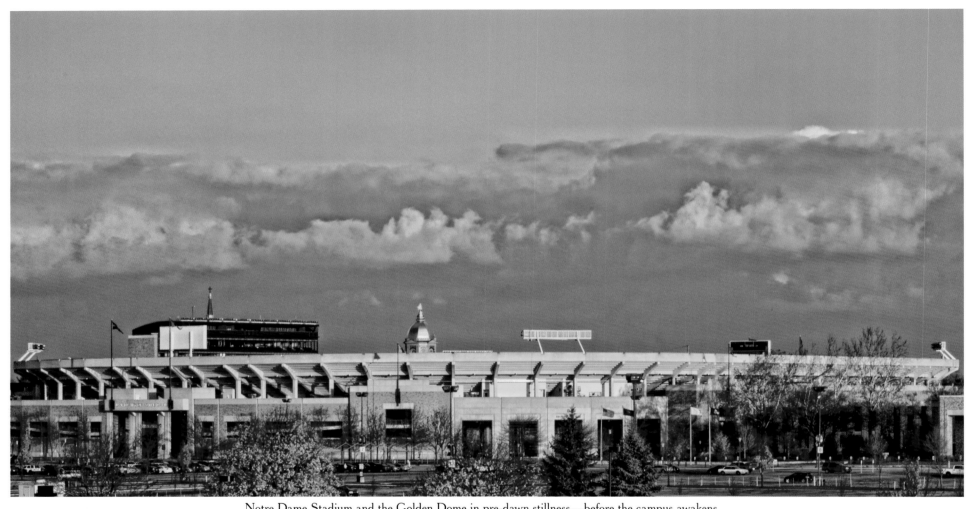

Notre Dame Stadium and the Golden Dome in pre-dawn stillness—before the campus awakens.

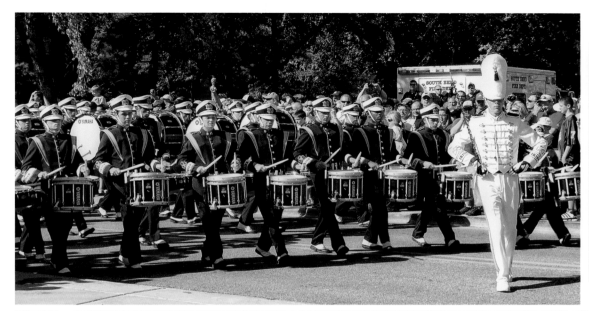

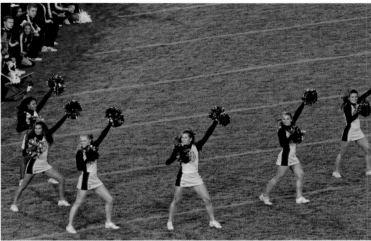

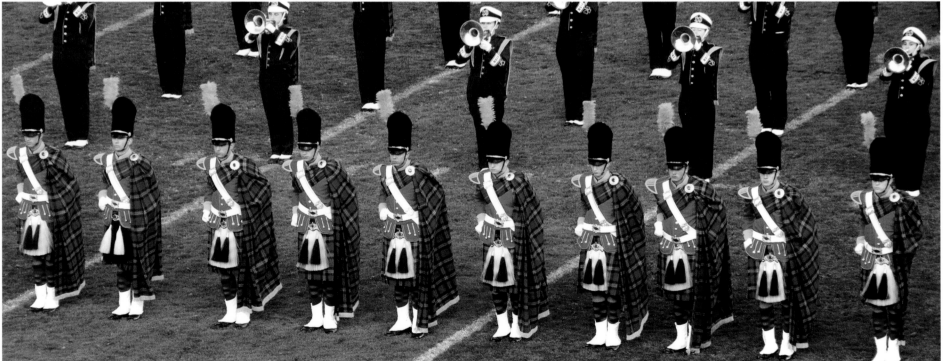

Win or lose, football ignites the campus on fall weekends. Crowds line the street to the stadium to hear the pounding drums and cheers, and watch the Irish Guard lead the band through the tunnel and onto the field.

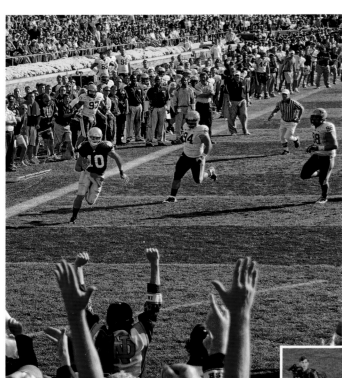

End-zone drama, cheerleaders, and singing the Alma Mater mark highlights of the fall football weekends and unite the ND family.

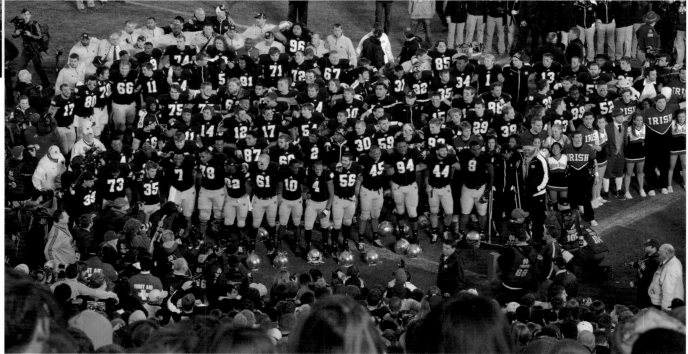

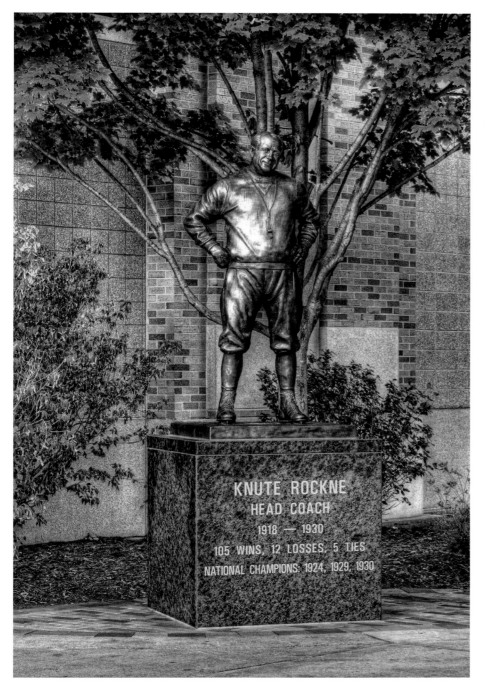

A life-size sculpture of Knute Rockne, Notre Dame's legendary coach, stands beside the "Rockne Gate" at the north entrance to the stadium.

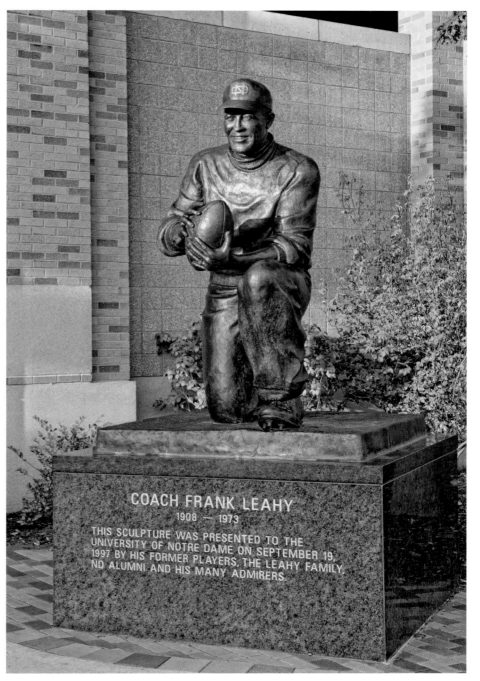

At the south entrance to the stadium, Coach Frank Leahy flashes a grin—his lads are winning.

"I can honestly say that the Notre Dame years were the greatest period of my life and my family's life. Our loyalty to and respect for Notre Dame will always be a part of me." – *Ara Parseghian*

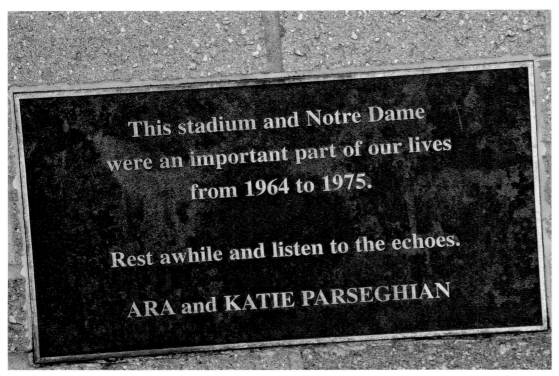

This stadium and Notre Dame were an important part of our lives from 1964 to 1975.

Rest awhile and listen to the echoes.

ARA and KATIE PARSEGHIAN

"I'd have to say that hiring Ara Parseghian was one of the smartest things we did."
– *Rev. Theodore M. Hesburgh, C.S.C.*

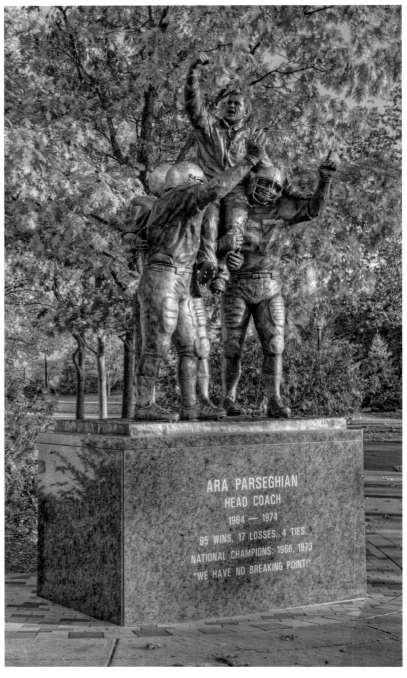

ARA PARSEGHIAN
HEAD COACH
1964 — 1974
95 WINS, 17 LOSSES, 4 TIES
NATIONAL CHAMPIONS: 1966, 1973
"WE HAVE NO BREAKING POINT!"

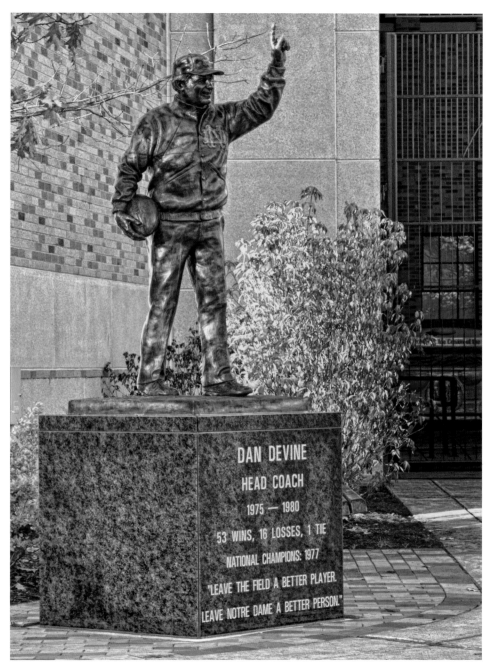

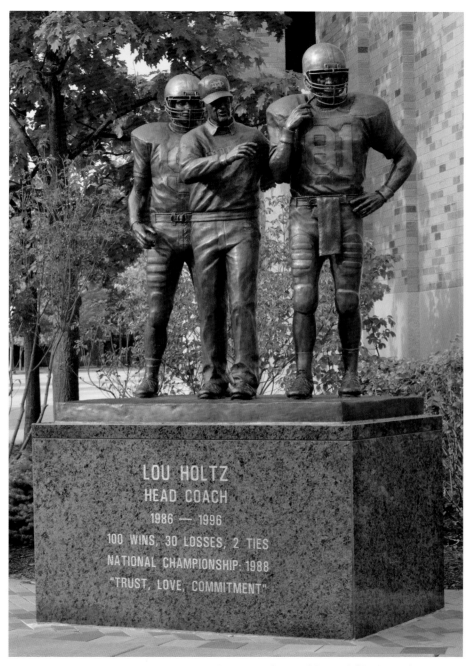

Coach Dan Devine wrote a page in Notre Dame's history book when, in 1977, the Irish took the field in Kelly green jerseys to crush USC. His 1979 team pulled off a miracle finish in the Cotton Bowl.

In the words of Lou Holtz, coach of Notre Dame's 1988 National Championship team: "People come to Notre Dame not to learn how to do something but to learn how to be somebody."

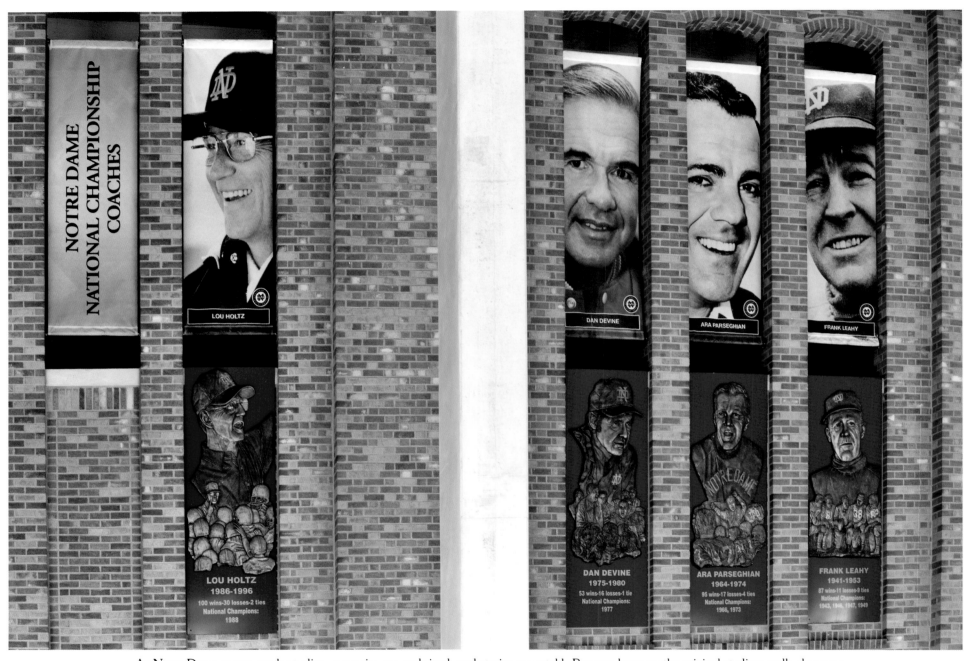

NOTRE DAME
NATIONAL CHAMPIONSHIP
COACHES

LOU HOLTZ

DAN DEVINE

ARA PARSEGHIAN

FRANK LEAHY

LOU HOLTZ
1986-1996
100 wins-30 losses-2 ties
National Champions:
1988

DAN DEVINE
1975-1980
53 wins-16 losses-1 tie
National Champions:
1977

ARA PARSEGHIAN
1964-1974
95 wins-17 losses-4 ties
National Champions:
1966, 1973

FRANK LEAHY
1941-1953
87 wins-11 losses-9 ties
National Champions:
1943, 1946, 1947, 1949

At Notre Dame names are kept alive, memories are enshrined, and stories are retold. Banners hung on the original stadium walls showcase the records of coaches who have led Notre Dame's football team to a national championship since WWII: Frank Leahy, Ara Parseghian, Dan Devine, and Lou Holtz. Each championship-winning coach, along with Knute Rockne, also has a stadium gate named after him.

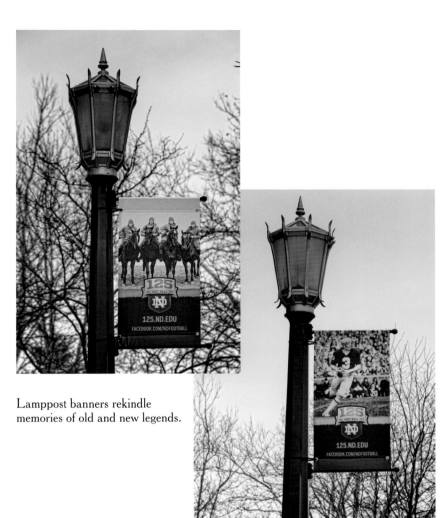

Lamppost banners rekindle memories of old and new legends.

A view through the Parseghian Gate reveals the walls of the pre-expansion stadium which was built in 1930 to Coach Rockne's specifications. The dusty cinder track that surrounded the stadium is now a faint memory.

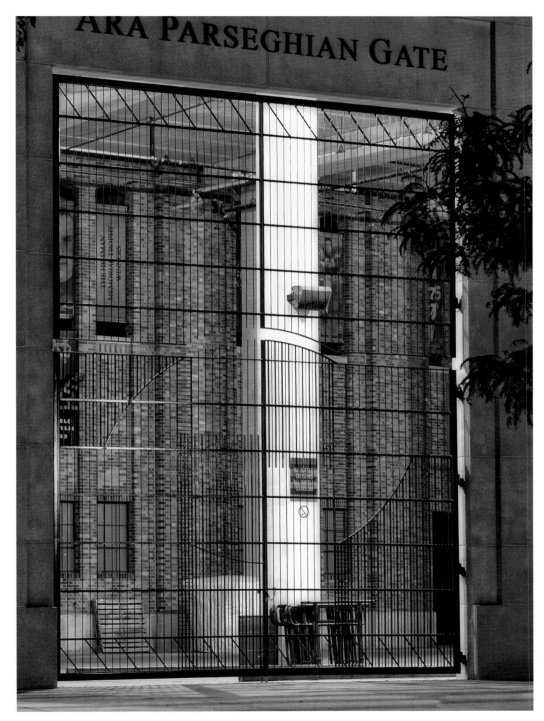

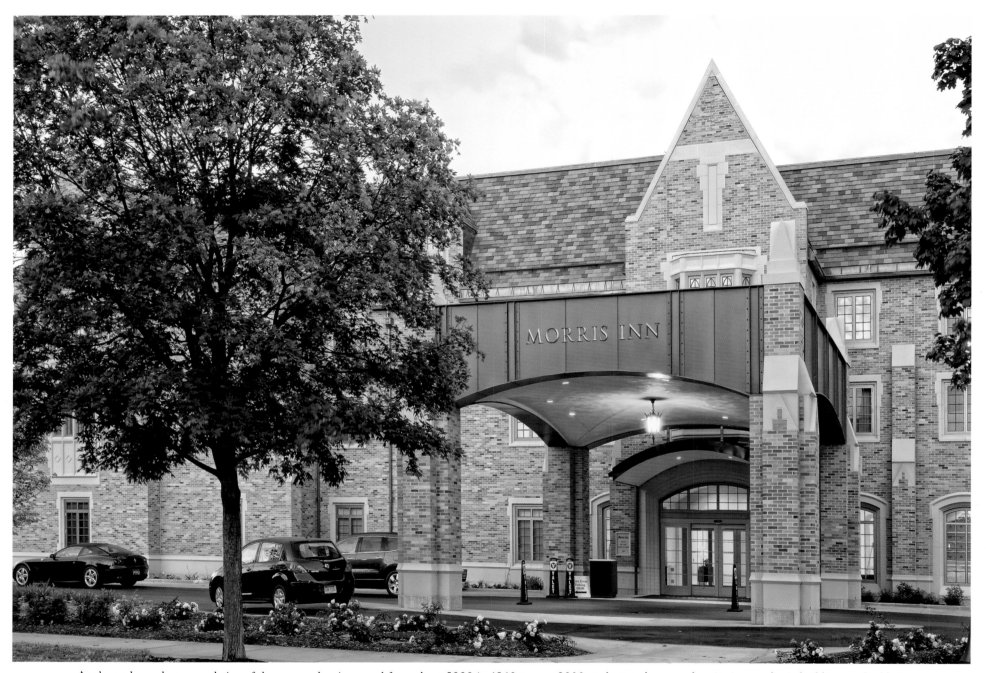

As the undergraduate population of the campus has increased from about 5000 in 1960 to over 8000 students today, new dormitories, academic buildings and athletic facilities have dramatically increased the size of the campus and transformed its face. Even the '50s-era Morris Inn has been remodeled and expanded. Older graduates still recognize the campus of their time, and marvel at Notre Dame's ongoing development.

The renovated Morris Inn reopened for the fall football season in 2013. Its expansion will allow more alums to acquire on-campus lodging during football weekends.

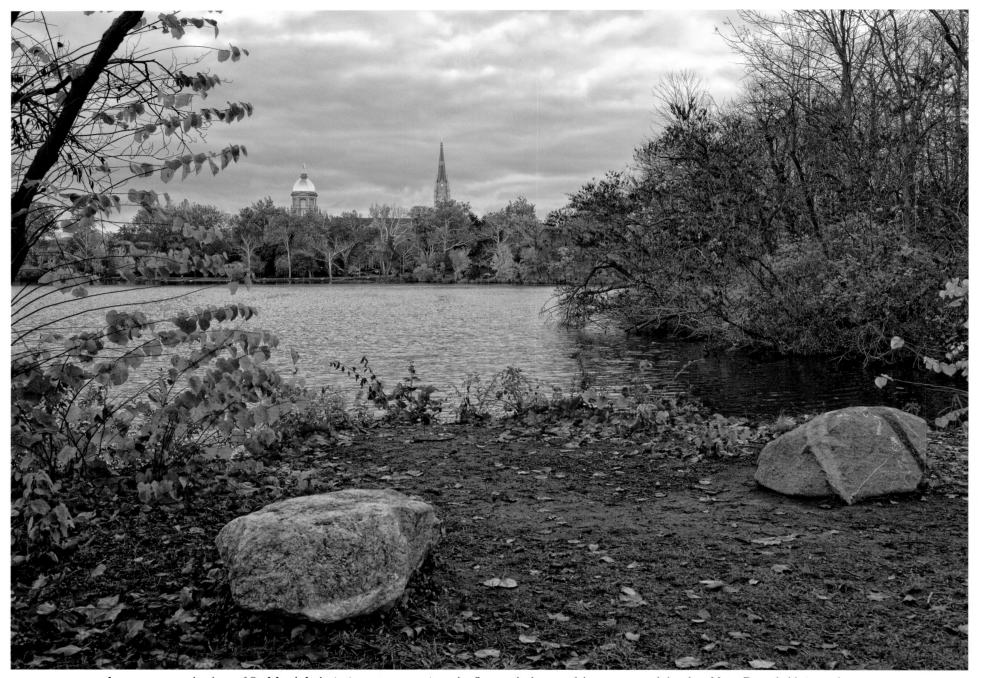

Large stones on the shore of St. Mary's Lake invite us to pause, sit, and reflect on the beauty of the campus, and the place Notre Dame holds in our hearts.